# BUTCH HEROES

# BUTCH HEROES

Ria Brodell

The MIT Press
Cambridge, Massachusetts
London, England

Library of Congress Cataloging-in-Publication Data
Names: Brodell, Ria, author.
Title: Butch heroes / Ria Brodell.
Description: Cambridge, MA : The MIT Press, 2018. | Includes bibliographical references.
Identifiers: LCCN 2018008759 | ISBN 9780262038973 (hardcover : alk. paper)
Subjects: LCSH: Brodell, Ria. Butch heroes. | Gender-nonconforming people--Portraits. | Gender-nonconforming people--Biography.

Classification: LCC ND1329.B756 A62 2018 | DDC 759.13--dc23 LC record available at https://lccn.loc.gov/2018008759

10   9   8   7   6   5   4   3   2   1

To those who came before

# Contents

# Acknowledgments

Thank you to the writers and scholars who make LGBTQIA history their life's work; without your tireless research this project would not exist. Special thanks to those who responded to my queries, Professor Sharyn Graham Davies, Makeda Silvera, Professor Dr. Saskia E. Wieringa, Professor Christina Woolner, and Professor Emily Skidmore. Thank you to Anjaree Thailand, Vicente Guzman-Orozco, Mamiko Imoto, and Tomomi for translation and research assistance.

This project was made possible in part by the financial support of Artadia: The Fund for Art and Dialogue, the SMFA Traveling Fellowship, the Massachusetts Cultural Council, and the Berkshire Taconic Community Foundation, and with the generous support of Louis Wiley Jr.

Thank you to Arlette Kayafas for the opportunity to exhibit the paintings, to Pendred Noyce for graciously editing the initial text, to Georgie Friedman for your encouragement, painting checks ("I think you made the hands too big"), and proofreading. And, thanks to my brothers, Nick and Chris, for fine-tuning the manuscript.

Thank you to all those who have emailed me throughout the process to offer me encouragement, corrections or suggestions. Keep them coming, I'm still working!

# Introduction

I started this project in 2010 after making the painting *Self Portrait as a Nun or Monk, circa 1250*. I was thinking about what my life would have been like had I been born into a different century. Joining the church, becoming a nun or a monk, was one option for those who did not want to enter into a heterosexual marriage or conform to the strict gender roles of their time. As a former Catholic, I knew that "homosexuals" were called to a lifetime of chastity or service to the church, but I supposed that queer people of the past must have found other ways to live, and I wanted to find out how they did so.

I started by going to the LGBTQIA sections of local libraries, including Boston Public Library and the libraries at Tufts University and Boston College, and scouring books on our history for names and stories. Finding the names of actual individuals, as opposed to just generalized stories or legends, is the most difficult part of such research. It requires reading between the lines because so much of queer history has been explained away as illness, romantic friendship, opportunistic cross-dressing, or fraud, or is rewritten or censored to suit the time period.

For this project, I was looking for people in history with whom I can personally identify—people who were assigned female at birth, had documented relationships with women, and whose gender presentation was more masculine than feminine. I searched for people from diverse ethnic, societal, and geographic backgrounds, and who were born before or around the turn of the twentieth century. Some of my subjects identified as women, others as men; some shifted between gender presentations throughout their lives, while others embodied both simultaneously. I use the narratives of their lives to establish their place in this project. Though some could be identified today with the terms "lesbian," "transgender," "nonbinary," "genderqueer," "intersex," etc., these myriad LGBTQIA terms were not available to them during their lifetimes. Since it is impossible to know exactly how each person would self-identify using today's terminology, I view this project as an ongoing effort to document a shared history within the LGBTQIA community.

I include each person's chosen name(s) and given name for historical accuracy and to aid in research purposes. To determine pronoun use, I refer to their gender presentation or chosen name at each point in their story. If it is uncertain, I use "she or he," "him/her," "they," or just their name(s).

Once I found a name and a story that interested me, I tried to get access to the original source, which might be a newspaper article or a personal journal entry, for example. I looked for anything that included the subject's own voice, and hopefully a description of them. I tried to find other sources to verify the information. I summarize their stories here and include my sources so that others can access the original material. Each portrait involved extensive research into all aspects of the person's life, social class, occupation, clothing, and environment. I strove to be historically accurate and culturally sensitive to each individual.

Each painting was a new challenge and a different journey into history. I used descriptive accounts and other sources, such as artifacts, maps, journals, paintings, drawings, prints, or photos from the time period to help me create a real or imagined portrait of the subject. Figuring out how to represent aspects of their lives visually was the best part. For example, I've been in the basement of the Cabot Science Library at Harvard, handling and taking notes from one of Olga Tsuberbiller's dusty textbooks; I scoured old maps of Stockholm trying to determine what the skyline would have looked like from the Haymarket in 1679; I examined buffalo robes from the National Museum of the American Indian and at the Peabody Essex Museum; and I watched YouTube videos of a father and son team (with thick Scottish accents) demonstrating how to properly plaster a traditional Scottish house for John Oliver's portrait. I loved gathering the details.

Using the format of the Catholic holy card was a personal and logical stylistic choice for me. I still have a collection of holy cards that belonged to my late aunt. I loved going through the collection with her and hearing her tell the stories of the saints. They are beautiful, intimate objects. They're also handed out at funerals to help honor deceased family members, used to commemorate special events, or even just exchanged between friends and family as kindly gestures. When I was a child the saints depicted on the holy cards were presented to me as role models. They are figures from church history that are revered, one is meant to look to them for guidance or to help find peace. For me, this format is a perfect (subversive) way to present the lives of people who were long forgotten and abused during their lifetime, especially because so many of them were accused of "mocking God and His order" or deceiving their fellow Christians.

Finally, I have chosen the term "Butch" for my title because of its dual nature: it has been slung as an insult and used as a congratulatory recognition of strength. It has a history within the LGBTQIA community and is familiar to the cisgender, heterosexual community. In addition to the term's traditional associations of being masculine in appearance or actions, I chose to use "Butch Heroes" to indicate people who were strong or brave in the way they lived their lives and challenged their societies' strict gender roles.

# List of Portraits

# The Paintings

# Katherina Hetzeldorfer

Katherina Hetzeldorfer was tried, and then drowned in the Rhine, for a crime that didn't have a name in 1477.

Hetzeldorfer had moved to the city of Speier, Germany, from Nuremberg with a woman who, during the trial, Hetzeldorfer claimed was a sister. They had lived in Speier for two years before Hetzeldorfer was arrested. The two had apparently confided in members of the community, describing the nature of their relationship as being like that of a husband and wife. After intense cross-examination, Hetzeldorfer revealed that the woman was not a sibling, but that they had had a long-standing sexual relationship. (Hetzeldorfer's wife may have escaped, because her words are not recorded in the trial transcripts.)

Female witnesses who claimed to have been seduced by Hetzeldorfer described him/her as "being like a man in both physique and behavior, a sexually aggressive character and a potent lover."[1] Hetzeldorfer and these witnesses were made to describe in detail how it was that Hetzeldorfer acted like a man; their answers included the description of the use of an "instrument" and how it was made: "with a red piece of leather, at the front filled with cotton, and a wooden stick stuck into it, and made a hole through the wooden stick, put a string through, and tied it round."[2] It was the use of this "instrument," combined with Hetzeldorfer's gender transgressions, that led to death by drowning, a particularly demeaning sentence reserved for women.

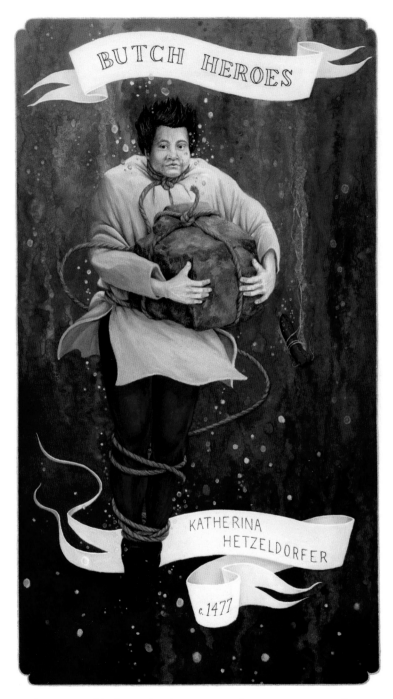

**Katherina Hetzeldorfer** c. 1477 Germany, gouache on paper, 11 x 7 inches, 2012 Collection of the Davis Museum at Wellesley College

# Elena aka Eleno de Céspedes

Elena, also known as Eleno de Céspedes, was a freed slave born in Alhama, Spain, in 1545. Her father was a Castilian peasant and her mother an African slave, so Elena had brand marks on both sides of her face to indicate her status as the off-spring of a slave. She was married at age sixteen to a man who left her shortly after she became pregnant. According to her testimony before the Spanish Inquisition in 1587, while giving birth to her son, she grew a penis.[3] She gave the baby to another family and proceeded to live sometimes as a woman and sometimes as a man. Céspedes moved from town to town working as a tailor, a hosier, a soldier, and finally a licensed surgeon, using whichever gender suited the occasion.

Céspedes had many affairs with women, but in 1586 he became engaged to Maria del Caño. When he asked the vicar for a marriage license, the vicar became suspicious of Céspedes' hairless physique and had him examined by his associates. The vicar's men testified that all was intact. However, before the marriage could occur, someone came forward and claimed that Céspedes was both male and female, so the vicar wanted them examined again. Céspedes was examined multiple times by doctors, surgeons, lawyers, the Secretary of the Inquisition, and other people of "good repute," all of whom confirmed that he was indeed male, and the wedding was finally allowed to proceed. However, a year later, after a tip from a neighbor, the couple was arrested and charged with sodomy, sorcery, and disrespect for the marriage sacrament.

When testifying before the Tribunal of Toledo, Céspedes professed to be a "hermaphrodite" and to have both male and female natures.[4] Céspedes argued that at the time of his marriage to Maria, he had been of the male nature and had therefore committed no wrong. However, his male member had recently withered and fallen off due to a serious accident. After more examinations by court doctors and midwives, Céspedes was found to be a woman and was sentenced for bigamy, fakery, perjury, and mockery of the sacrament of marriage. Céspedes received two hundred lashes and was ordered to serve ten years in a public hospital, dressed as a woman.

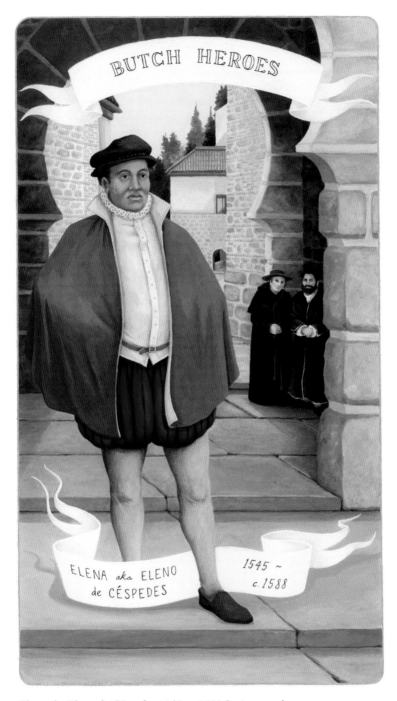

**Elena aka Eleno de Céspedes** 1545–c. 1588 Spain, gouache on paper,
11 x 7 inches, 2011 Collection of the Davis Museum at Wellesley College

# Mary de Chaumont en Bassigni

While traveling across Europe in 1580, Michel de Montaigne, a French writer and philosopher, recorded in his journal the story of Mary de Chaumont en Bassigni.

While staying at Vitry le François, he heard about an execution that had occurred just a few days before in the nearby town of Montier en Der. According to his record, the story began several years before when seven or eight girls from Chaumont en Bassigni made the collective decision to dress and live as men. They went their separate ways, but one of them, "under the name Mary,"[5] settled in Vitry.

They earned their living as a weaver, and were described as a well-behaved, likable young man who made friends with everyone. They were engaged to a woman in Vitry, but because of a disagreement that arose, the engagement was called off, so they moved to Montier en Der.

In Montier en Der they fell in love and married a young woman. The couple lived happily together for four or five months before someone from Chaumont recognized "Mary." At that point, the matter was brought to the attention of authorities, and "the husband was condemned to be hanged; which she said she would rather endure than reassume her female attire and habits. And she was accordingly hanged, on the charge of having, by unlawful practices and inventions, supplied the defects of her sex."[6]

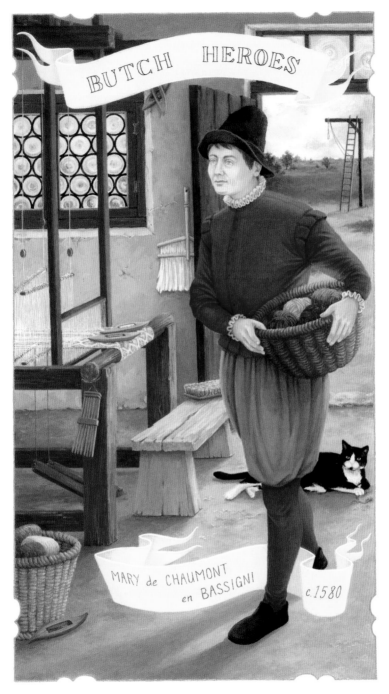

**Mary de Chaumont en Bassigni** c. 1580 France, gouache on paper,
11 x 7 inches, 2015 Collection of the Davis Museum at Wellesley College

# D. Catalina "Antonio" de Erauso

Catalina de Erauso was born in San Sebastián, Spain, to a noble Basque family. She was raised in a convent from an early age but before taking her vows fled dressed in men's clothes and assumed the name Francisco de Loyola.

Francisco worked as a page for a few years before deciding to seek adventure in the New World, sailing to Panama as a cabin boy. After arriving in New Spain, he enlisted in the Spanish army under the name Alonso Díaz Ramírez de Guzmán. He became a successful soldier in Chile and Peru, even advancing to the rank of captain. However, like many other soldiers, he got into frequent brawls, had trouble with women, and accumulated gambling debts. After deserting the army, pursued by authorities for various offenses, including murder, he was eventually wounded in a duel. Believed to be on the verge of death, he revealed that he was a woman and was placed in a convent.

After recovering and trying to escape, Erauso confessed everything to a bishop and was examined by midwives, who found that she was indeed a woman and a virgin. Released, she traveled back to Spain, but the story had spread and Catalina de Erauso became a celebrity known as the "Lieutenant Nun." She petitioned King Philip IV for a military pension, citing her fifteen years of service to the crown in New Spain. She also visited Pope Urban VIII with a request to be allowed to continue to dress as a man, referencing her status as a virgin and her defense of the Catholic faith.

With the permission of the pope and a pension from the Spanish government, Erauso returned to New Spain as Antonio de Erauso and retired as a mule driver and merchant.

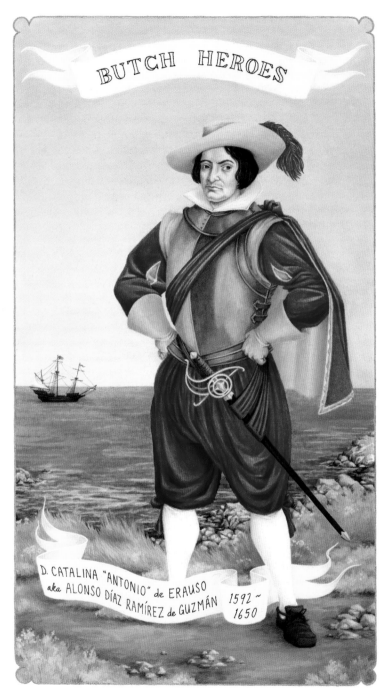

**D. Catalina "Antonio" de Erauso** 1592–1650 New Spain, gouache on paper, 11 x 7 inches, 2011 Collection of the Leslie-Lohman Museum

# Lisbetha Olsdotter aka Mats Ersson

Lisbetha Olsdotter was originally from Östuna Parish in Långhundra District, Uppland, in Sweden. Leaving behind a husband and two children, Lisbetha found work as a servant, a farmhand, and finally as a soldier under the name Mats Ersson.

According to the records, Lisbetha had assistance from a soldier's wife, Sara, and a skipper, Erik Persson Arnelii.[7] They kept her history secret, and Arnelii helped her enlist as a soldier. Mats Ersson performed all of his duties as a soldier and married, in a church ceremony, the maid Kjerstin Ersdotter.

On October 24, 1679, Mats Ersson was brought before the Svea Court of Appeals in Stockholm and charged with maliciously deserting their husband and two children; wearing male clothing and disguising themself as a man, which was an abomination and a great offense to God; bigamy, for marrying twice and deceiving a woman; publicly mocking God's sacred order and the customary ceremonies of the community and the Fatherland by marrying another woman in the church of God; theft, for taking payment as a soldier and spending it; and fraud, for taking a profession they were not capable of performing, i.e., soldier.[8]

They were found guilty of all charges under county law by the Religious Charter of 1655. For intentionally mutating their sex, mocking God and His order, and deceiving their fellow Christians, they were sentenced to decapitation by axe. Due to the unusual nature of the case, it was sent to the Royal Court for review.

On November 12, 1679, the Royal Court confirmed the verdict, and it was decided that Mats would go to their execution in male clothing but wearing a female headdress. They were decapitated on Hötorget (Haymarket square) in Stockholm.

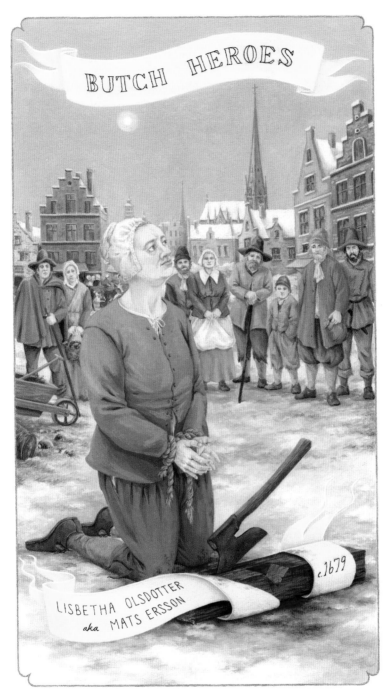

**Lisbetha Olsdotter aka Mats Ersson** c. 1679 Sweden, gouache on paper, 11 x 7 inches, 2013 Collection of the Davis Museum at Wellesley College

# Catharina Linck aka Anastasius

Catharina Margaretha Linck, also known as Anastasius Lagrantinus Rosenstengel, was executed for sodomy in Prussia in 1721. The trial records from the Prussian Secret State Archives were published in 1891 by Dr. F. C. Müller and translated into English by Brigitte Eriksson in 1980.

Catharina Linck or Anastasius Rosenstengel lived sometimes as a man, sometimes as a woman, and was employed variously as a prophet, a soldier, or a textile worker. Rosenstengel married Catharina Margaretha Mühlhahn at the age of twenty-three. The marriage was tumultuous, but they stayed together for four years. It was Mühlhahn's mother who eventually turned them in to authorities. At the trial Linck/Rosenstengel insisted that Mühlhahn and her mother had known "the truth" before their marriage.[9] Mühlhahn was sentenced to three years in prison and then banished from the country. Linck/Rosenstengel was convicted of sodomy, for wearing men's clothes, for frequent apostatizing, and for being baptized multiple times.

The court deliberated on an appropriate punishment, debating the use of a "lifeless leather device" and the criminal nature of female sodomy.[10] At the time, beheading by sword or burning alive was the punishment for male or female sodomy. Some jurists were unsure if the death penalty should apply to female sodomy since no "fleshly union" had occurred given the use of a "device."[11] The final verdict was left to King Frederick William I, who ordered Catharina Linck/ Anastasius Rosenstengel beheaded and the body burned.

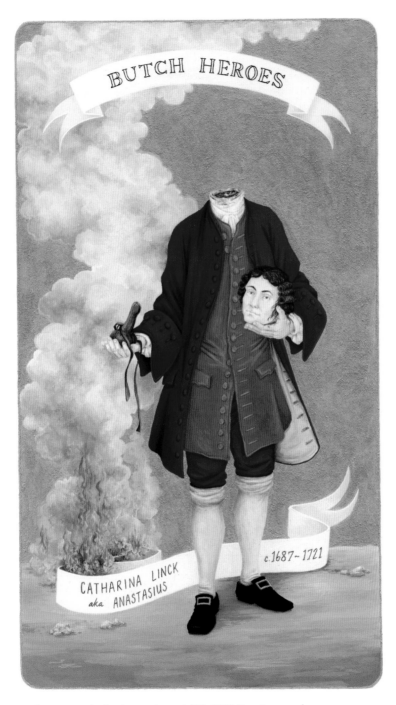

**Catharina Linck aka Anastasius** c. 1687–1721 Prussia, gouache on paper, 11 x 7 inches, 2010 Collection of the Davis Museum at Wellesley College

# Carl Lapp

Carl Lapp, a Sámi, died in 1694 in the Swedish parish of Hed. Upon his preparation for burial, his neighbors discovered that he had a female body. They reported this to their local pastor and eventually the matter was brought all the way to the High Court. Court records show that it was unclear what kind of burial "the Lapp,"[12] as he was known, should receive.

At the time of his death, Carl had been married to his second wife for thirteen years. She claimed that she did not know his sex, as they were elderly when they married and had never had sexual relations. However, he had a son with his first wife, both of whom had died. The court investigated the nature of his relationship with his wives and the existence of the child. They concluded that he was guilty of "participation in the sin of fornication that the former wife had carried on and kept it silent and hidden it, allowed the child to be baptized and recognized it as his own, and after his former wife's death, continued in his evil intent and grave sin with continued contempt for God's holy order."[13] The fact that he had deliberately "mutated" his sex combined with having repeatedly "abused the holy institution of marriage" warranted the death penalty under Swedish law.[14] Therefore, he was ordered to be buried in the forest instead of in the consecrated ground of the churchyard. Ironically, burial in the forest had long been a Sámi practice opposed by Swedish Christian clergy.[15]

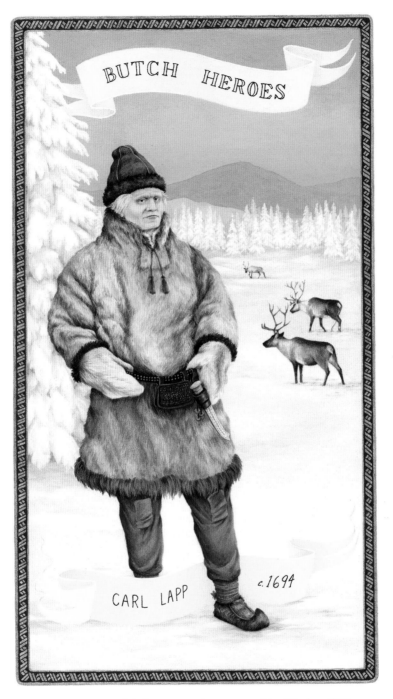

**Carl Lapp** c. 1674 Swedish Sápmi, gouache on paper, 11 x 7 inches, 2012

# James How aka Mary East & Mrs. How

Mary East and her wife (whose name is lost to history) met when they were teenagers. They lived as Mr. James How and Mrs. How for thirty-nine years, and ran a small public house at Epping, one at Limehouse, and then White Horse public house at Poplar in England. They were quite successful. James How was a foreman on juries and also served a number of parish offices, including headborough and overseer of the poor; at the time of his court appearance, he was under consideration for churchwarden. The Hows were a very private couple, but they had a good reputation with their neighbors and were well respected in their community.

Around 1750 someone who had known Mary East in her youth blackmailed them. Knowing that Mr. and Mrs. How were financially comfortable, the blackmailer wanted cash in exchange for keeping their secret. After threats of violence, the extortion became too intense. By 1766, unable to comply with the demands of the blackmailer any further, James How, dressed (awkwardly) as Mary East, brought the matter to the court. They were able to prove their extortion of considerable sums of money as well as assault, and won the case. The blackmailer was convicted and sentenced to stand three times in the pillory and four years of imprisonment. The public exposure, however, made it necessary for Mr. and Mrs. How to give up the White Horse and for James to resign all offices.

The *London Chronicle* report on August 7–9, 1766, claimed that they were both spurned by their male lovers and vowed never to take husbands, deciding instead (by the flip of a halfpenny) that Mary East should become James How and that they should live as man and wife.[16] Rictor Norton speculates in "Lesbian Marriages in 18th-Century England" that this story was probably fiction.[17] In actuality, this was likely a story created to provide an easy explanation for the heterosexual, cisgender public, who would have found their life hard to understand.

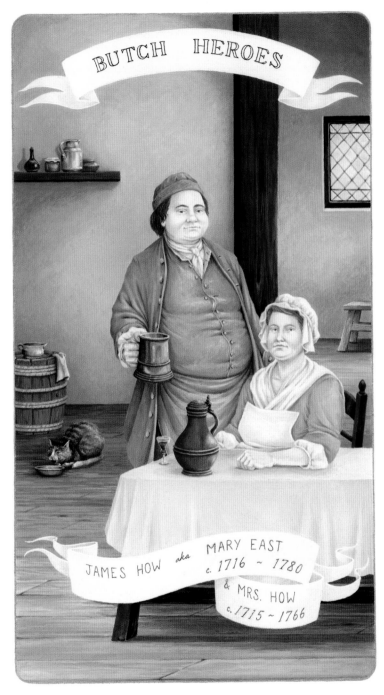

**James How aka Mary East & Mrs. How** c. 1716–1780 and c. 1715–1766
England, gouache on paper, 11 x 7 inches, 2011

# Catterina Vizzani
## aka Giovanni Bordoni

Catterina Vizzani was born in Rome to a carpenter's family. At age fourteen she fell in love with a girl who was teaching her embroidery. Catterina began to dress in men's clothes and visit the girl's window at night. Their relationship lasted for over two years, until the girl's father found out and threatened to turn Catterina over to the courts.

Catterina left Rome, dressed in men's clothes, and took the name Giovanni Bordoni. With the help of a priest, he got work as a vicar's servant in Perugia. The vicar was an austere man and complained of Giovanni "incessantly following the Wenches, and being so barefaced and insatiable in [his] Amours."[18] It was rumored that Giovanni was the best seducer of women in that part of the country. This reputation did not make the vicar happy, and he complained to the priest who had recommended Giovanni. The priest wrote to Giovanni's parents, who in turn told the priest everything. After learning the truth, the priest decided to keep Giovanni's secret.

After four years with the vicar, Giovanni left Perugia for Montepulciano, where he fell in love with the niece of the local minister. The minister was very protective of his niece, so the couple planned to secretly travel to Rome in order to be married. This plan was found out, and they were intercepted on their journey. During his attempt to surrender, Giovanni was shot in the left thigh, four inches above his knee.

In the hospital, suffering from gangrene, Giovanni's wound grew so painful that he was forced to remove the "leathern contrivance" that had been fastened just below the abdomen and hide it under his pillow.[19] On his deathbed he revealed to a nun that he was female and a virgin, and requested the ceremonial burial given to virgins. The body was laid out in the proper habit of a woman, with the virginal garland on the head and flowers strewn about the clothes.

A surgeon and professor of anatomy at Siena, Giovanni Bianchi, dissected the body in an attempt to find an explanation for "those who followed the practices of Sappho."[20] He examined it extensively, including removing and dissecting the hymen, clitoris, fallopian tubes, intestines, colon, gall bladder, and liver, finding everything in its "natural state."[21]

Catterina/Giovanni's funeral procession was extremely popular; people flocked from all parts of the city to get a view of the corpse. There were even attempts at canonization.

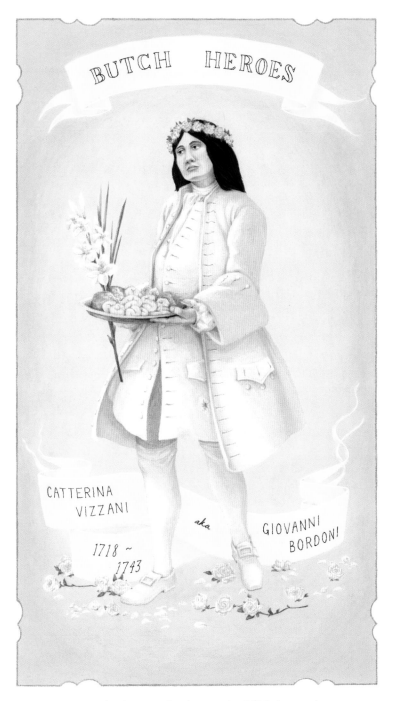

**Catterina Vizzani aka Giovanni Bordoni** 1718–1743 Italy, gouache on paper, 11 x 7 inches, 2012 Collection of the Davis Museum at Wellesley College

# Charles aka Mary Hamilton

Mary Hamilton left her home in Scotland wearing her brother's clothes at age fourteen, assumed the name Charles Hamilton, and took up an apprenticeship with a physician. In 1746, Charles Hamilton opened up his own practice and married Mary Price in Wells, England. In the months following their marriage, Mary Price declared that she had been deceived and that Charles Hamilton was actually Mary Hamilton.

The case went to trial and made headlines. Newspapers reported that Hamilton had married fourteen other women, though it is unclear if this was true as Hamilton was only prosecuted for deceiving Mary Price. There was much controversy over the nature of the crime. Specifically, what was the charge, what constituted polygamy, and was it still polygamy if the relationship was between women?

The verdict: "That the he or she prisoner at the bar is an uncommon, notorious cheat, and we, the Court, do sentence her, or him, whichever he or she may be, to be imprisoned six months, and during that time to be whipped in the towns of Taunton, Glastonbury, Wells and Shepton Mallet. ..."[22]

This history was fictionalized in Henry Fielding's popular story from 1746, *The Female Husband*.

By 1752, Hamilton may have ended up in Philadelphia, working as a doctor. Detained for fraud after having been discovered to be a woman, Hamilton was soon released because no one came forward with accusations.

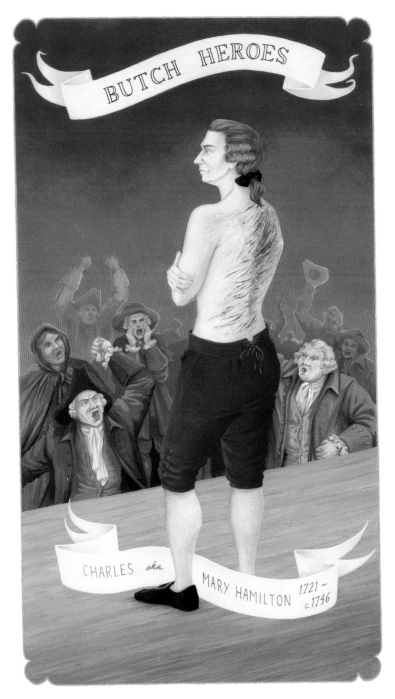

**Charles aka Mary Hamilton** 1721–c. 1746 England, gouache on paper,
11 x 7 inches, 2010

# Ann Marrow

Ann Marrow was convicted of fraud in July of 1777. She was found guilty of "going in men's clothes and personating a man in marriage, with three different women …, and defrauding them of their money and effects."[23] It is unclear if these accusations of theft were true, as there is no record of Marrow's side of the story. She was sentenced to three months in prison and to stand in the pillory at Charing Cross in London on July 22, 1777. It is said that she was pelted so severely by the spectators, "particularly the female part,"[24] that she was blinded in both eyes. Her fate after serving her sentence is unknown.

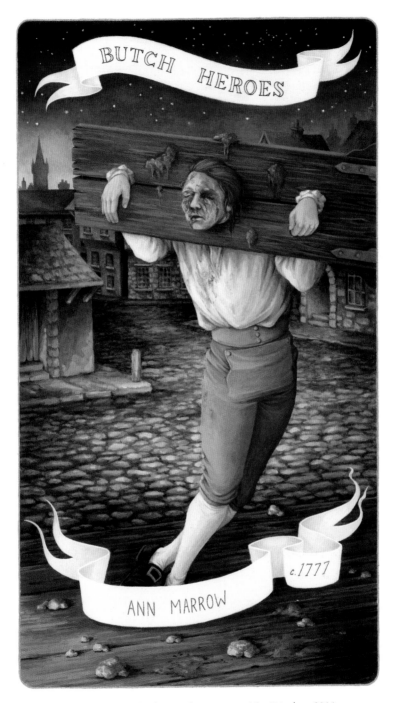

**Ann Marrow** c. 1777 England, gouache on paper, 11 x 7 inches, 2011
Collection of the Davis Museum at Wellesley College

# Sitting in the Water Grizzly

Sitting in the Water Grizzly was born into the Ktunaxa Nation (Kutenai or Kootenai). After leaving a marriage to a Canadian servant in which she was essentially a slave wife, she returned to her tribe, declaring that her husband had used supernatural powers to change her sex and she was henceforth a man. She changed her name to Kaúxuma Núpika, or Gone to the Spirits, adopted men's attire and weapons, and took a wife.[25]

Traveling extensively throughout the Pacific Northwest, Kaúxuma Núpika served as a courier and guide to the fur trappers and traders. To the tribes of the region he was a prophet (predicting large numbers of white men bringing diseases), a peace mediator, and a warrior. On one journey, after an unsuccessful trip to raid horses with other Ktunaxa warriors, Kaúxuma Núpika crouched down while crossing a stream so that his brother could not discern his sex, which had not physically been transformed. After this event he changed his name to Sitting in the Water Grizzly, or Qánqon Kámek Klaúla.[26]

Qánqon Kámek Klaúla was killed while trying to broker peace between the Salish and the Blackfeet. His death is described as magical, his wounds healing each time he was struck, until finally his enemy had to cut out his heart. He is remembered as a hero, a healer, and a supernatural being.[27]

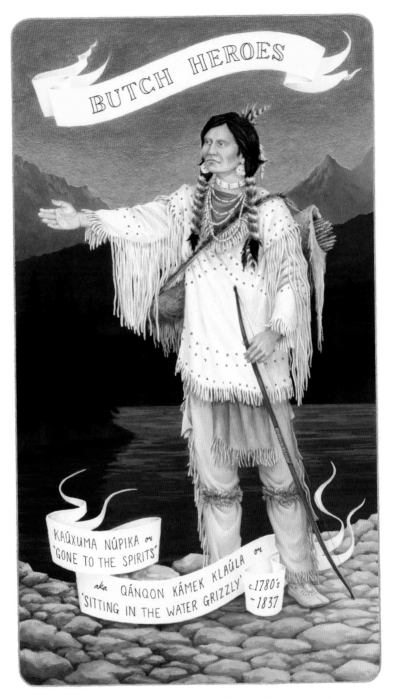

**Sitting in the Water Grizzly** c. 1780's–1837 Ktunaxa Nation, gouache on paper, 11 x 7 inches, 2011 Collection of the Leslie-Lohman Museum

# Enriqueta aka Enrique Favez

According to Enrique Favez's testimony during their trial, they were born Henriette in Lausanne, Switzerland, in 1791.[28] After the death of her parents, she was placed in the custody of an uncle. Her uncle, in an effort to correct what he perceived as her "troublesome masculine demeanor," arranged for her marriage at age fifteen to an officer in Napoleon's army.[29] However, Favez was soon widowed and took the opportunity to start again.

Favez moved to Paris to study medicine, taking the name Enrique. He received his degree and enlisted in Napoleon's army as a surgeon. He served through the rest of the Napoleonic Wars, afterwards emigrating to Cuba.

In Cuba, he established a practice in the community of Baracoa. It was rural and poor, so he would travel great distances to provide healthcare, as well as to teach reading and writing, to people in the surrounding areas. In the town of Tiguabos he met and fell in love with a woman named Juana de León. On August 11, 1819, Favez married Juana at Our Lady of the Assumption in Baracoa.

Their marriage seemed to be happy. Favez was a sought-after doctor with a good reputation, and the two were a popular couple. They had many close friends and hosted parties in their home. One day, a housekeeper entered the bedroom and found Favez asleep on the bed with his shirt unbuttoned. Realizing what she was seeing, she could not contain herself and shared the news, which quickly spread.

Favez was arrested and put on trial. The list of charges included "falsification of documents, perjury, incitement to violence, illegal practice of medicine, rape, desecration of the Catholic sacrament of marriage and imposture."[30] Juana insisted that she had been deceived. She admitted to suspecting that their marriage had been consummated "in an artificial way" (i.e., through the use of a "fictitious instrument").[31] Favez repeatedly denied any deception, insisting that Juana knew everything before their marriage. Juana demanded that Favez be physically examined. The examination by a panel of experts found Favez to be "effectively a woman."[32]

Favez denied any wrongdoing: "I have not harmed anyone but rather have done a very considerable good" as a doctor serving the community.[33] Favez went on to explain that they always had a "naturally strange character … a strong propensity for masculine manners,"[34] and that they had married Juana out of love.

The judge sentenced Favez to ten years in prison and exiled them from all Spanish territories. Favez appealed, attempted escape, and even tried to commit suicide. In July 1824 Favez was extradited to New Orleans where they had family.

Upon arriving in New Orleans, Favez is reported to have joined the Daughters of Charity at the insistence of family members; however, the Daughters of Charity have no record of Favez ever joining the order. Favez's death was recorded in New Orleans on October 17, 1856.

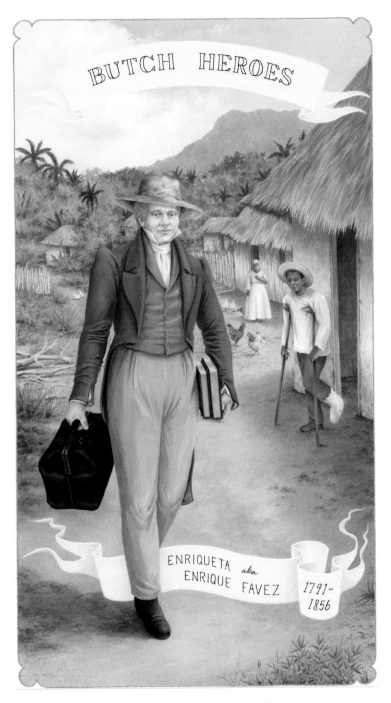

**Enriqueta aka Enrique Favez** 1791–1856 Cuba, gouache on paper,
11 x 7 inches, 2017

# Helen Oliver aka John Oliver

When Helen Oliver was in her late teens or early twenties, she worked as a maid on a farm in West Kilbride, Scotland. It was reported that "a particular intimacy took place" between her and a ploughman at a neighboring house. They were "frequently seen walking together in queit [sic] and sequestrated places, they were regarded as lovers; ultimately however this 'ploughman' turned out to be also a female."[35]

Soon thereafter, Helen left her home in Saltcoats dressed in her brother's clothes and assumed the name John Oliver or sometimes John Thomson. John went to live with a cousin in Glasgow and learned the plastering business. As a journeyman plasterer he moved from town to town in search of employment (sometimes working as a flesher or weaver as well). While working in Johnstone, John courted and married a young woman. Six months after their marriage, John was forced to leave town because he was recognized by a man from Saltcoats who knew his parents. At least twice his identity was published in broadsides like the *Glasgow Chronicle*, under the description "Rustic D'Eon" or "eccentric character."[36] Each time his identity was revealed, John was forced to relocate and seek new employment.

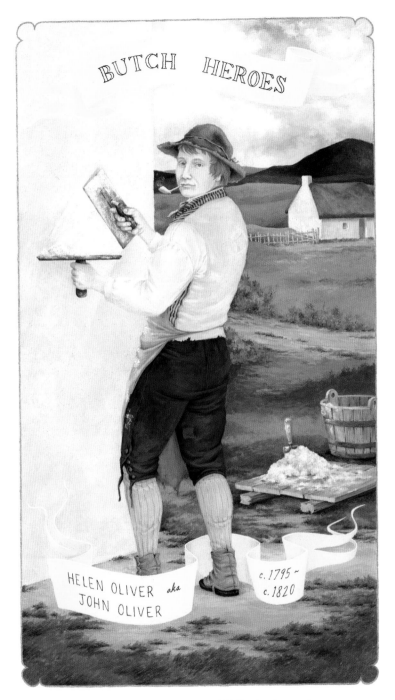

**Helen Oliver aka John Oliver** c. 1795–c. 1820 Scotland, gouache on paper, 11 x 7 inches, 2011

# Biawacheeitche or Woman Chief

Biawacheeitche, or Woman Chief, was born to the Gros Ventre tribe in western North America. She was captured and adopted by the Apsáalooke (Crow) nation when she was ten. At an early age she showed an inclination toward male pursuits. According to Edwin Thompson Denig, a fur trader who knew her for several years, she could "rival any of the young men in all their amusements and occupations."[37] She was "fearless in everything" and adept at hunting and warfare. She led large war parties and was recognized as the third-highest leader in a band of 160 lodges. Although she wore the dress of a woman, she kept up "all the style of a man and chief, [she] has her guns, bows, lances, war horses, and even two or three young women as wives ... [and] the devices on her robe represent some of her brave acts."[38] In 1854 she was killed by the Gros Ventre near Fort Union.

Her story was popularized in James Beckwourth's memoirs, in which she is referred to as Pine Leaf. Beckwourth was an emancipated slave, fur trader, and mountain man who apparently fell in love with Woman Chief. After refusing his proposals of marriage multiple times, she finally conceded that she would marry him only "when the pine leaves turn yellow."[39] Later Beckwourth realized that pine leaves do not turn yellow.

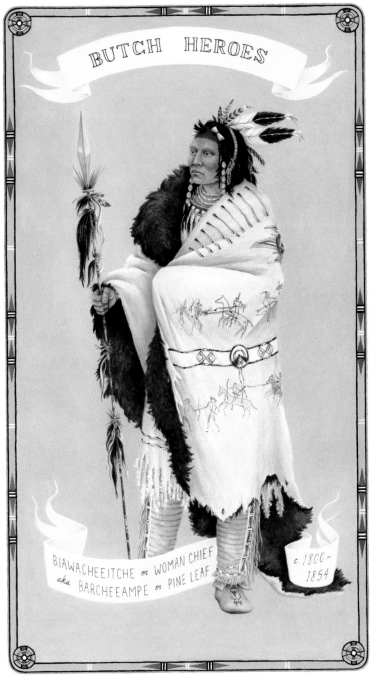

**Biawacheeitche or Woman Chief aka Barcheeampe or Pine Leaf** c. 1800–1854
Apsáalooke Nation, gouache on paper, 11 x 7 inches, 2011 Collection of the Davis
Museum at Wellesley College, Gift of Louis Wiley, Jr.

# Rosa Bonheur

Rosa Bonheur was a nineteenth-century French painter and sculptor. She was one of the first renowned painters of animals and was the first woman to be awarded the Grand Cross of the French Legion of Honor. An extremely popular artist during her lifetime, she exhibited at the Paris salon regularly.

Often mistaken for a man because of her short-cropped hair and strong features, she was granted permission by the police commissioner to wear men's attire while painting. She was married twice, first to her childhood sweetheart Nathalie Micas in a private family ceremony conducted by Nathalie's father, and after Nathalie's death to American artist Anna Klumpke.[40]

Bonheur was extremely successful financially. This allowed her to purchase Château By, a house and farm, near the Fontainebleau Forest and to pay off her father's debts. She also supported her siblings throughout her life, despite their objections to her lifestyle. Bonheur consistently defended her independence and her relationships with Micas and Klumpke. She used her last will and testament to force legal recognition of her right to transfer her property to another woman.[41]

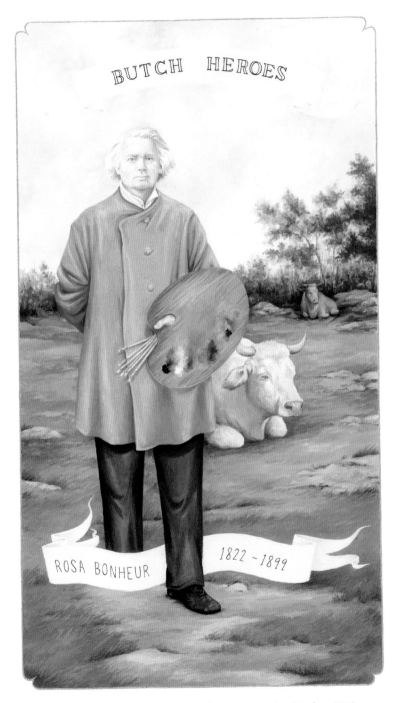

BUTCH HEROES

ROSA BONHEUR          1822 ~ 1899

**Rosa Bonheur** 1822–1899 France, gouache on paper, 11 x 7 inches, 2010
Collection of the Davis Museum at Wellesley College

# Billy or Sammy Williams

Sammy Williams died of apoplexy in Manhattan, Montana, on December 10, 1908. He was reportedly between sixty-eight and eighty years old. Upon preparation for Williams's burial, a "deathbed discovery" was made: the body was female.

Williams had worked as a lumberjack and a camp cook throughout Montana, the Dakotas, Iowa, and Wisconsin. He had lived in Gallatin County, Montana, for eighteen years. By the time of his death, he had accumulated an estate that included over three hundred acres of land. Apart from the occasional joke about his lack of facial hair, no one had suspected anything, so his death prompted a number of questions. A local resident who remembered seeing him many years earlier in Eau Claire, Wisconsin, wrote to the Chief of Police in Eau Claire in an attempt to gather more information. He received prompt confirmation that Sammy had lived in Wisconsin in the 1870s, but had gone by the name Billy.[42]

Williams was described as short and stout, with black hair, a soft voice, and a slight hunchback. He was "strong as an ox," and drank, smoked, chewed, and cursed like the rest of his friends. Though his friends admitted to not knowing much about his past, their recollections of Sammy/Billy were positive. He was very popular, respected, and charitable. Many recounted his frequent donations to the poor and visits to the sick or elderly. He was "always willing to lend a hand." Others recalled that "he never hesitated to go out with the lumberjacks and spend money in the saloons." He was "a great ladies man" who liked to take the girls out dancing.[43] Letters found among his personal effects revealed that he had several love affairs with women over the years.[44]

Speculation ran wild after Williams's death as newspapers struggled for explanations. Was "she" spurned by a lover at an early age and thus decided to live as a man? Was it a prank, or the result of a quarrel with "her" parents? Did "she" do it to survive financially? Or, perhaps "she" was just a "strange character"? One version of the story garnered more attention than the others. It suggested that Williams had been a heartbroken Norwegian named Ingeborge Weken who had been jilted as a young girl by her fiancé and thus took up life in the lumber camps.[45] Although this tale quickly spread throughout the country's newspapers, scholars Peter Boag[46] and Emily Skidmore say it was likely a fanciful tale, a way of "rendering him understandable to mainstream readers."[47]

On December 12, 1908, Williams was laid to rest. His friends organized the funeral service and collected money for a granite headstone that still stands in Manhattan's Meadowbrook Cemetery today.

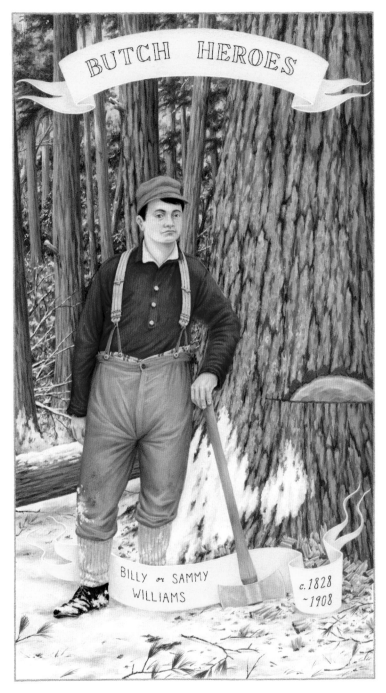

**Billy or Sammy Williams** c. 1828–1908 United States, gouache on paper, 11 x 7 inches, 2017 Collection of the Minnesota Museum of American Art

# Captain Wright

On Sunday, December 14, 1834, an "Extraordinary Discovery" was published in *The Bell's New Weekly Messenger*, a London newspaper. For two consecutive Sundays the newspaper highlighted the personal story of Mr. Wright, known as Captain Wright.

For five years, Mr. and Mrs. Wright had lived at Kennington Lane as husband and wife. They were by all accounts "respectable gentlefolks."[48] Captain Wright was known as a jovial fellow who walked with a swagger and was fairly heavyset for his diminutive stature of four feet five inches tall. He frequented the nearby public houses, enjoying immensely his glass of grog, his pipe, and the company of "pretty girls," as he was fond of saying.[49]

He was also very fond of rabbits, of which he kept and bred an abundance. Finding them a "delightful and interesting study," he would apparently go on and on about them to anyone who would listen, even going so far as to wager large sums of money on their reproductive powers.[50]

The newspaper recounts that when Captain Wright died, the body was found to be female, a "beard only excepted." Of course, large crowds of curious neighbors came to view the body, now referred to as a "creature" by the newspaper.[51] Rumors quickly spread as people attempted to guess at the reasons behind the Captain's "disguise"—property inheritance and blackmail were among the many guesses.

His coffin was engraved with the name Eliza Wright.

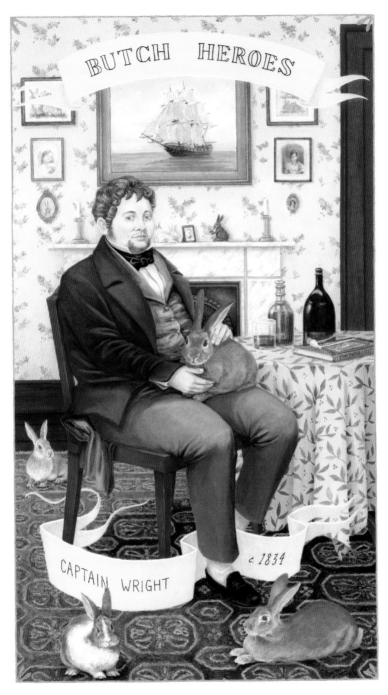

**Captain Wright** c. 1834 England, gouache on paper, 11 x 7 inches, 2016
Collection of the Davis Museum at Wellesley College, Gift of Louis Wiley, Jr.

# Okuhara Seiko & Watanabe Seiran

Okuhara Seiko was a literati artist of the late Edo and early Meiji period. A painter, calligrapher, poet, teacher, and martial artist, Seiko was born with the name Setsuko in the domain of Koga, to a high-ranking family of the samurai class. Young Setsuko would normally have been subjected to an arranged marriage, but her class allowed for some freedom. Girls were not permitted to study painting as apprentices in the traditional workshop studios, so instead Setsuko received private training from various artists and scholars, gaining a well-rounded and diverse literati education.

At twenty-eight, Setsuko wished to move to the capital of Edo (now Tokyo) to begin a career as an artist. However, laws in late Edo-period Koga forbade women from leaving the clan lands, so Setsuko arranged to be adopted by an aunt in the neighboring clan of Sekiyado, which had no restrictions on women's travel.[52]

Shortly after arriving in Edo, around 1865, she changed her name from Setsuko to Seiko, a name that gives no indication of gender, meaning "clear lake."[53] Seiko was a masculine, robust figure, wearing men's clothes and short hair in a male style. A gregarious personality, quick wit, creativity, and penchant for conversation made Seiko an extremely popular and sought-after personality at scholarly gatherings and parties. It did not take long for Seiko to become an established artist. Seiko was the first female artist to have an audience with the Empress, and Seiko's home became a favorite gathering place for artistic and literary leaders of the day.

Seiko opened a coed school in the early 1870s. Seiko believed that girls who were serious about their education needed a place to study away from the demands of home. The school grew, reaching upward of three hundred students, including geisha.

Watanabe Seiran, originally one of Seiko's students, was Seiko's companion of more than forty years. Seiran was a talented painter in her own right. Not only did she manage the household and studio affairs, but she helped with the creation of commissioned works and the training of students. She was also responsible for the numerous study works and sketches necessary for the completion of paintings. Seiran emulated Seiko's style so perfectly that it is difficult to tell their work apart without a signature.

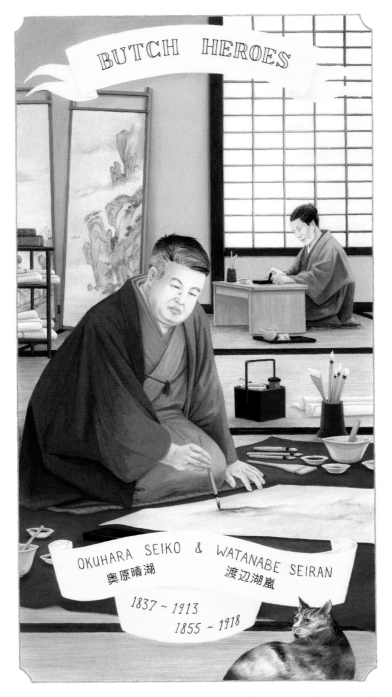

BUTCH HEROES

OKUHARA SEIKO & WATANABE SEIRAN
奥原晴湖　　　　渡辺湖嵐

1837 ~ 1913
1855 ~ 1918

**Okuhara Seiko & Watanabe Seiran** 1837–1913 and 1855–1918 Japan, gouache on paper, 11 x 7 inches, 2013 Collection of the Davis Museum at Wellesley College

# Jeanne or Jean Bonnet

Jeanne or Jean Bonnet was born in Paris but moved to San Francisco with their family as part of a French theatrical troupe. By the time Bonnet was fifteen, he was in trouble for fighting and petty thievery, and was placed in the Industrial School, San Francisco's first reform school.

As an adult, Bonnet was arrested dozens of times for wearing male clothing, an illegal act that got him frequently mentioned in the press. Bonnet "cursed the day she was born a female instead of a male," according to newspaper accounts. He was quoted as declaring, "The police might arrest me as often as they wish—I will never discard male attire as long as I live."[54]

Bonnet spent much of his time on Kearny Street and made a fairly good living by catching frogs and selling them to French restaurants in downtown San Francisco. In 1875 he began visiting brothels, convincing the women to leave prostitution and form an all-female gang. Together they supported themselves by shoplifting. One of these gang members was Blanche Buneau or Beunon, who had just arrived from Paris.

Bonnet and Blanche moved to McNamara's Hotel in San Miguel, just outside of San Francisco, to keep Blanche safe from a threatening ex-lover. On the evening of September 14, 1876, Bonnet was lying in bed waiting for Blanche when a shotgun blast came through the window, killing him instantly. It was eventually determined that the shot was meant for Blanche and was the act of either a jealous lover or a pimp wanting to kill Blanche as "an example to the other girls."[55] Unfortunately, neither theory was ever proven. The women of San Francisco's red-light district came out en masse for Bonnet's funeral.[56]

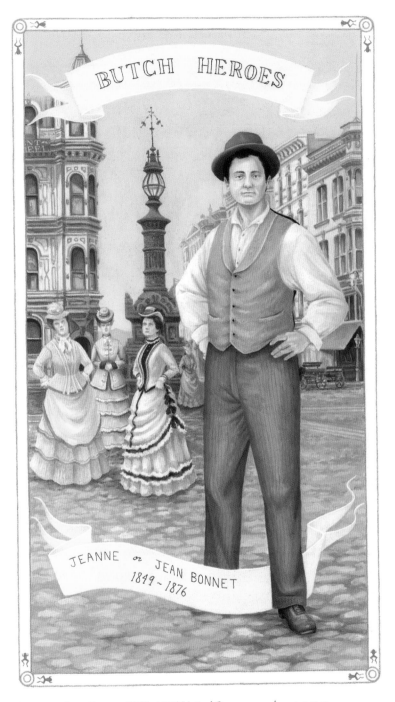

**Jeanne or Jean Bonnet** 1849–1876 United States, gouache on paper,
11 x 7 inches, 2012 Collection of the Henry Art Gallery

# Cora Anderson aka Ralph Kerwineo

On a spring day in 1914, Milwaukee police arrested Ralph Kerwineo just as he was lighting a cigarette outside his place of employment. Described as "well-dressed" and "the perfect gentleman," he was ushered into the police car and charged with disorderly conduct for wearing male attire.[57] His former wife, Mamie White, had reported him for abandonment and outed him as female.

Ralph was born Cora Anderson on April 6, 1876, in Kendallville, Indiana. Her father was an African American barber and her mother was Potawatomi-Cherokee. At age twenty-four, Cora moved to Chicago. She was working as a nurse and living in a boarding house on the South Side when she met Mamie White. Soon the two were living together. In 1906 they left Chicago as husband and wife, first moving to Cleveland and then to Milwaukee, where Ralph got a job as a clerk at the Cutler-Hammer Company.

Ralph and Mamie lived together as a married couple for over ten years before Ralph met and fell in love with another woman, Dorothy Kleinowski. Ralph and Mamie's relationship had not been going well and the two were separated. Mamie had become increasingly annoyed by Ralph's new habits, smoking, frequenting poolrooms, and coming home late at night, but she did not know that Ralph had married Dorothy in front of a justice of the peace. Consumed by jealousy, she reported Ralph, first to his employer and then to the police.

During the trial Mamie stated, "We wanted to be together, so we rented a room and the people with whom we lived never doubted that we were man and wife."[58] Ralph professed that they wanted "to live honest lives and become respected citizens of the community."[59] He said, "My heart and soul are more those of a man than a woman."[60] In addition, Ralph explained he could find work more easily when passing as a man of Bolivian or Spanish descent than as a mixed-race woman. The Milwaukee public was sympathetic. They saw him as someone who was just trying to provide support for his wife and make a living. The charges were dropped on the condition that Ralph would go back to wearing female attire.

The trial attracted national attention. Afterwards, Cora Anderson wrote about living as Ralph Kerwineo and shared observations about how men act when women aren't around. The fame also resulted in a traveling vaudeville act, but soon money and employment dried up. In 1915 Anderson/Kerwineo was arrested in Racine, Wisconsin, after "masquerading as a man" and failing to pay for a hotel room.[61] In 1919 they were accused of stealing, and when the cops arrived at the apartment, they found Anderson/Kerwineo in bed with a female companion. In defense, Anderson/Kerwineo claimed to have been married for a year, but left their husband due to disagreements. In both cases Anderson/Kerwineo was released on probation. After 1919 there is no more mention of the name Ralph Kerwineo or Cora Anderson in the newspapers.

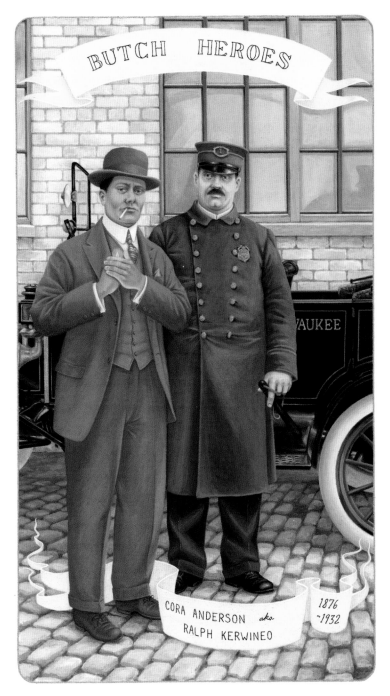

**Cora Anderson aka Ralph Kerwineo** 1876–1932 United States, gouache
on paper, 11 x 7 inches, 2017 Collection of the Cornell Fine Arts Museum

# Petra "Pedro" Ruiz

According to the National Defense Archives in Mexico City, Petra Ruiz was born in Acapulco in December 1893 and died in Mexico City in February 1938.

Petra is recorded as enlisting in the Constitutionalist Army in 1913 under the name Pedro Ruiz. The disguise—male clothing and short, cropped hair—was so perfect that no one was suspicious. Pedro Ruiz quickly rose to the rank of lieutenant, fighting for Venustiano Carranza against Victoriano Huerta's forces.

Lieutenant Ruiz soon established a reputation as an accomplished fighter with a thirst for adventure and a violent temper. He competed fiercely for the love of women.[62] His fellow soldiers are said to have feared him, earning him the nickname "El Echa Balas" or "Bullet Slinger"[63] because of his sharp shooting skills and abilities with a knife.

On one occasion Lieutenant Ruiz's battalion took control of a hacienda while fighting in Oaxaca, killing the owner. The soldiers argued over who would be the first to rape the owner's young daughter. Hearing her screams, Lieutenant Ruiz rode in with guns blazing and said, "I'm taking this one, and if any of you don't like it, you can tangle with me!"[64] The soldiers backed off, and Lieutenant Ruiz rode off with the girl. Once they were far enough away, Lieutenant Ruiz opened her shirt to reassure the girl that she was safe, saying, "I'm also a woman like you."[65] Upon reaching the nearest town, she left the girl with a family who would keep her safe. She was later quoted as saying, "I joined the Constitutionalist Army as a way to survive, but above all, to avert whenever possible the rape of more women, such as the one I suffered."[66]

Toward the end of the war, newly instituted President Venustiano Carranza was reviewing the troops, and as he was walking past, Lieutenant Ruiz stepped forward and said, "Mr. President, since there's no more fighting, I want to ask for my discharge from the army, but first I want you to know that a woman has served you as a soldier."[67] Those assembled were amazed, and Carranza immediately called for an investigation into the life of Lieutenant Ruiz.

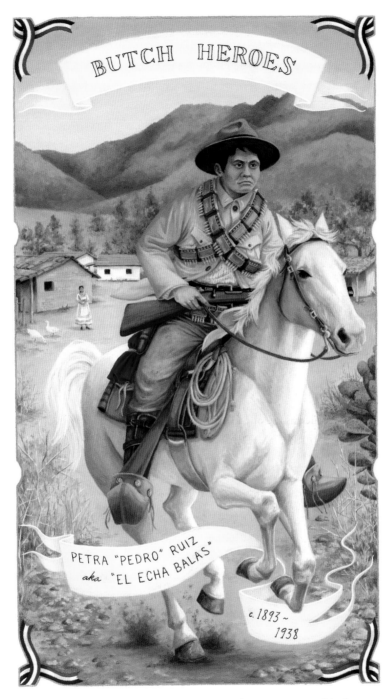

**Petra "Pedro" Ruiz** c. 1893–1938 Mexico, gouache on paper, 11 x 7 inches, 2013 Collection of the Davis Museum at Wellesley College

# Frank Blunt & Gertrude Field

Annie Morris, also known as Frank Blunt, a native of Halifax, Nova Scotia, left an abusive home at the age of thirteen with a younger brother, and lived as Frank Blunt for fifteen years before being arrested on larceny charges.

The following was published in *The Badger State Banner* of Black River Falls, Wisconsin, on January 18, 1894:

## ANNA MORRIS GIVEN ONE YEAR

Anna Morris, alias Frank Blunt, the woman who has tried to be a man for the last fifteen years, was sentenced to the penitentiary for one year by Judge Gilson at Fond du Lac. She was arrested several months ago in Milwaukee charged with stealing $175 in Fond du Lac. It was then discovered that the prisoner was a woman, although she had worn masculine attire nearly all her life. A jury convicted her of larceny and a motion for a new trial was overruled. After the sentence had been passed Gertrude Field, a woman who claimed to have married the prisoner in Eau Claire, fell upon the neck of the prisoner and wept for half an hour. This woman has furnished all the money for Blunt's defense, and now proposes to carry the case to the Supreme Court.

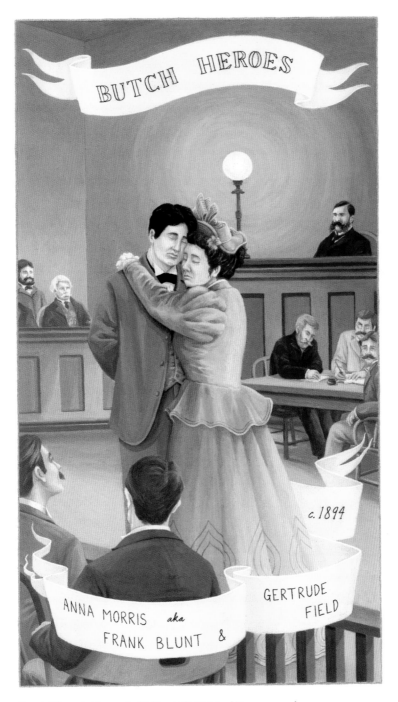

**Frank Blunt & Gertrude Field** c. 1894 United States, gouache on paper,
11 x 7 inches, 2012 Collection of the Minnesota Museum of American Art

# Olga Nikolaevna Tsuberbiller

Olga Nikolaevna Tsuberbiller was born in Moscow in 1885. Her father worked for the Chinese Eastern Railway, while her mother kept the farm and raised Olga and her older brother. Olga Nikolaevna graduated from the physics and mathematics department of Moscow University for Women in 1908, and soon afterward she began to lecture on analytical geometry. She was a professor and head of the department of higher mathematics in the department of chemistry, as well as head of the engineering mechanics department at Moscow State University of Fine Chemical Technology (МИТХТ).

Olga Nikolaevna was a dedicated educator. At the University for Women, she organized a math library and reading room, in an effort to help students understand scientific literature. She spent many hours counseling and tutoring students, guiding student groups, and advising undergraduate and graduate students. A gifted speaker, Olga worked to popularize the mathematical sciences. She published a number of books and scientific papers that played a significant role in the preparation, education, and development of engineers, scientists, students, and academic researchers. One of her books, *Problems and Exercises in Analytic Geometry*, was published more than thirty-five times in Russian and was translated into Czech, Polish, German, and Chinese. It became the standard math textbook in Soviet high schools and is still used by students in mathematics and technical institutes.

Olga Nikolaevna was described by her friends and family as "even-tempered, serious, and good-hearted."[68] She could subtly and tactfully guide a conversation, and she worked "like an ox" to support those she loved, which included not only her mother but also her older brother's two children and, later, her companion, Sophia Parnok.

Olga Nikolaevna met the poet Sophia Parnok in 1923. Openly lesbian, Parnok wrote about her sexuality, love affairs, and lesbian experience. The two lived together for nearly ten years. Olga Nikolaevna provided stability for Parnok both emotionally and financially; Parnok believed Olga to be her "angel" sent to protect her. When Parnok died in 1933, Olga Nikolaevna took responsibility for her manuscripts and memoirs.

After Parnok's death, Olga Nikolaevna met the writer, teacher, spiritualist, and opera singer Concordia "Cora" Antarova. Cora and Olga Nikolaevna lived through the Second World War together, during which time Cora was constantly under surveillance for her writing related to spirituality. In Cora's later years, Olga Nikolaevna again filled the role of caretaker and protector until Cora died in 1959.

In 1969, after almost sixty years at МИТХТ, Olga Nikolaevna retired. She died on September 28, 1975, at the age of ninety and was buried in the Novodevichy Cemetery in Moscow next to Cora Antarova.

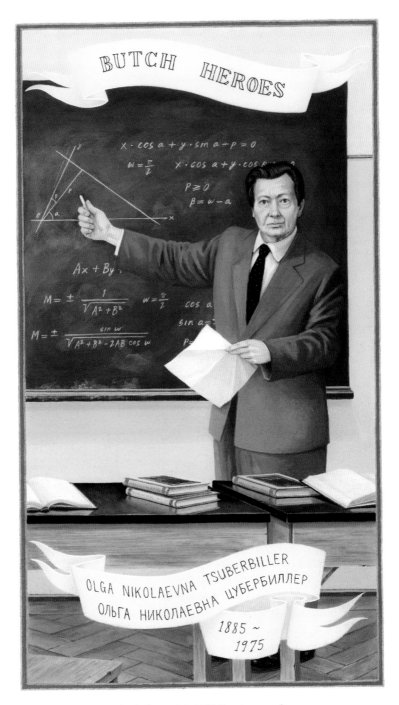

**Olga Nikolaevna Tsuberbiller** 1885–1975 Russia, gouache on paper,
11 x 7 inches, 2014. Collection of the Cornell Fine Arts Museum.

# Naa Jian

Naa Jian lived in a rural village in the province of Ayuthaya, Thailand.

In her book *Toms and Dees*, Megan Sinnott records an interview with Ing, a relative of Naa Jian, who described Naa Jian's mannerisms as being "like a man," saying that it was "just the way she was." Naa Jian was a respected member of the community and "did all men's work—fished (with a net), did farming, all the heavy work." Naa Jian lived with a woman named Ee Iat, "like husband and wife." According to Ing, if anyone flirted with Ee Iat, Naa Jian would get angry. "At first they had a houseboat together. Then they had a big house and a rice field together." Naa Jian supported Ee Iat, and they lived together for such a long time that, Ing said, "If Naa Jian were a man, he would have children and grandchildren by now."[69]

Ing recalled that Naa Jian had been married to a man before, but they did not get along and had no children. The husband would get drunk and Naa Jian would beat him. He ended up leaving Naa Jian for another woman. Naa Jian told him, "Go ahead and leave. I don't want you anyway."[70]

Ee Iat's nephew lived in another district. He wanted company and asked if she would come to live with him. Naa Jian was devastated when Ee Iat agreed, exclaiming, "This house is for us to live in together. If you're going to leave, this land and house are mine. If you want to go, you just take yourself and get out of here." According to Ing, Naa Jian gave Ee Iat fifty thousand baht and told her, "Okay, now we're broken up. You don't need to come back anymore. If I die, I'll give all the rest of my property to the temple." Later, Ee Iat came back, but Naa Jian would not have her.[71]

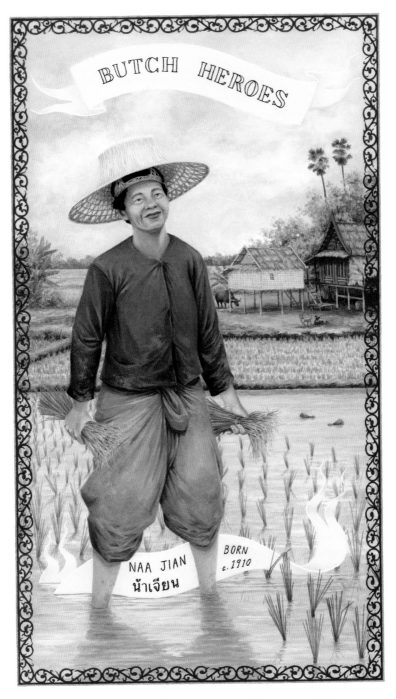

**Naa Jian** born c. 1910 Thailand, gouache on paper, 11 x 7 inches, 2015
Collection of the Davis Museum at Wellesley College

# Jones or Jonesie

In her essay "Man Royals and Sodomites: Some Thoughts on the Invisibility of Afro-Caribbean Lesbians," Makeda Silvera recounts conversations with her grandmother and mother about the lesbian women in their community. One of those women was Jones or Jonesie, as she was known.

Jonesie lived in Kingston, Jamaica. Described as a "mannish-looking Indian Woman with flashy gold teeth," she was loud and brazen, but generous and easy to talk to. She dressed in her husband's clothes, smoked Craven A cigarettes, and could often be found in her yard with her dogs, "always barefoot and tending to her garden and her fruit trees." She had the best mangoes on the street and would always share.[72]

Silvera's mother remembers Jonesie keeping to herself, except for when she would visit their veranda. On the veranda she talked to anyone, and would spend her time drinking, smoking, and reminiscing about her past—especially about her love of women. She would say things like, "Dem girls I use to have sex with was shapely. You shoulda know me when I was younger, pretty, and shapely just like the 'omen dem I use to have as my 'omen."[73] She would brag that she could go to Coronation Market and pick up any woman she wanted.

Ordinarily in Jamaica at that time, if you were deemed a "man royal" or a "sodomite," you were in danger of repercussions, especially if you were unmarried. Those repercussions ranged from social ostracism to battery or even gang rape. The fact that Jonesie was married provided her with a certain amount of protection. People made fun of her not because she was a lesbian, but because she would stumble home drunk from the rum shop. Jonesie was tough, though, and could take care of herself. No one would really mess with her, and she threatened to beat up anybody who tried.[74]

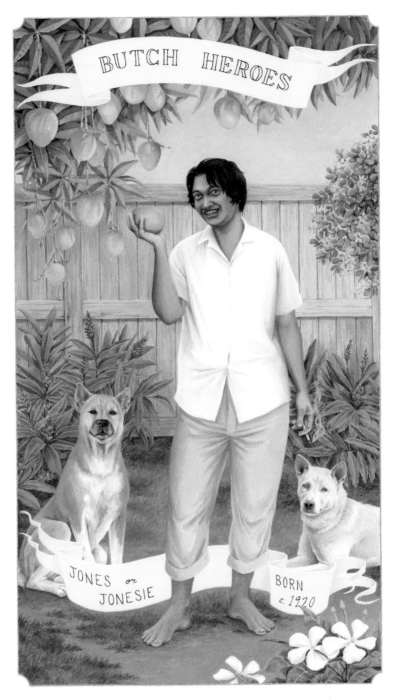

**Jones or Jonesie** born c. 1920 Jamaica, gouache on paper, 11 x 7 inches, 2017

# Clara aka "Big Ben

Clara, better known as "Big Ben" because of her size, masculine mannerisms, preference for male attire, and "attention to other women," is described in the account of a murder that took place at a rent party in New York's Columbus Hill neighborhood. The *New York Age* published the story of the murder on November 17, 1926. According to the article, Big Ben was not at the party, but was the cause of a fight between two women, Reba Stobtoff and Louise Wright. Stobtoff was apparently jealous of Wright's attentions toward Big Ben and attacked her, warning her to stay away from the "man woman." The fight ended with Stobtoff cutting Wright's throat, resulting in her death.

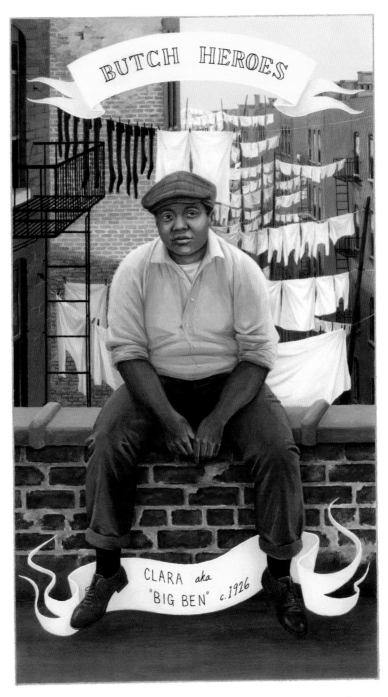

**Clara aka "Big Ben"** c. 1926 United States, gouache on paper, 11 x 7 inches, 2014 Collection of the Davis Museum at Wellesley College

# Sakuma Hideka & Chiyoka

In 1934, Sakuma Hideka and Chiyoka worked at a coffee shop in Tokyo together with another (unnamed) woman. Newspaper accounts of their story describe the three women as having a polyamorous relationship that they knew society would never condone.

Knowing that they could not live as a couple or a threesome, Hideka and Chiyoka embarked on a journey to commit shinjū (double suicide or "love suicide") by jumping into Mount Mihara, an active volcano on the island of Ōshima off the coast of Tokyo.

Meanwhile, unbeknownst to them, the third woman attempted to commit suicide on her own, leaving farewell notes to her family. Alerted by these notes, the press learned of Hideka and Chiyoka's intentions and followed them to Ōshima, catching up to them before they could throw themselves into the crater.

Afterwards, Hideka wrote her own account of the incident, describing their two-day journey to Mount Mihara, their stay at an inn, and how they held each other close, "thinking only of death."[75] She criticized the press for spreading rumors about her family, disparaging her masculine appearance, and trivializing their suicide attempt by asking readers to contribute satirical songs about it. She also expressed her loneliness and wondered why self-sufficient women in love could not live together just as heterosexual couples did.[76]

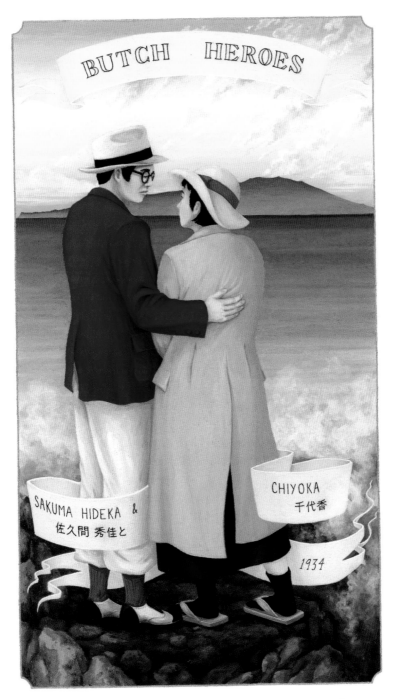

**Sakuma Hideka & Chiyoka** 1934 Japan, gouache on paper, 11 x 7 inches, 2012 Collection of the Leslie-Lohman Museum

# Notes

### Katherina Hetzeldorfer

1. Helmut Puff, "Female Sodomy: The Trial of Katherina Hetzeldorfer (1477)," *Journal of Medieval and Early Modern Studies* 30, no. 1 (2000): 43.

2. Ibid., 46.

### Elena aka Eleno de Céspedes

3. Sherry Velasco, *Lesbians in Early Modern Spain* (Nashville, TN: Vanderbilt University Press, 2011), 75.

4. Israel Burshatin, "Written on the Body: Slave or Hermaphrodite in Sixteenth-Century Spain," in *Queer Iberia: Sexualities, Cultures, and Crossings from the Middle Ages to the Renaissance*, ed. Josiah Blackmore and Gregory S. Hutcheson (Durham, NC: Duke University Press, 1999), 427.

### Mary de Chaumont en Bassigni

5. Michel de Montaigne, *Works of Michel de Montaigne: Comprising His Essays, Journey into Italy, and Letters*, ed. William Hazlitt (Boston, MA: Houghton, Mifflin and Company, 1887), 188. Their only name recorded is "Mary"; if they had an alternative chosen name, it was lost to history.

6. Ibid., 189.

### Lisbetha Olsdotter aka Mats Ersson

7. P. G. Berg and Wilhelmina Stålberg, "Olsdotter, Lisbetha," *Anteckningar om Svenska Qvinnor* (1864): 292–293, accessed November 24, 2012, http://runeberg.org/sqvinnor/0324.html.

8. Ibid., 292.

## Catharina Linck aka Anastasius

9. Louis Crompton, *Homosexuality and Civilization* (Cambridge, MA: Harvard University Press, 2003), 474.

10. Brigitte Eriksson, "A Lesbian Execution in Germany, 1721: The Trial Records," *Journal of Homosexuality* 6, no. 1–2 (Fall 1980–Winter 1981): 37–39.

11. Ibid., 40.

## Carl Lapp

12. Gunlög Fur, "Reading Margins: Colonial Encounters in Sápmi and Lenapehoking in the Seventeenth and Eighteenth Centuries," *Feminist Studies* 32, no. 3 (Fall 2006): 496. Naming him "the Lapp" is a reference to the former name for the Sámi people, Laplanders.

13. Quoted in Fur, "Reading Margins," 496. No citation given other than "records."

14. Ibid., 496–497.

15. Ibid., 498.

## James How aka Mary East & Mrs. How

16. Rictor Norton, ed., "Mary East, the Female Husband," *Homosexuality in Eighteenth-Century England: A Sourcebook*, December 6, 2003, http://rictornorton. co.uk/eighteen/1766east.htm, accessed February 27, 2018.

17. Rictor Norton, "Lesbian Marriages in 18th-Century England," *Homosexuality in Eighteenth-Century England: A Sourcebook,* August 18, 2009, updated February 11, 2010, http://rictornorton.co.uk/eighteen/lesbmarr.htm, accessed February 27, 2018.

## Catterina Vizzani aka Giovanni Bordoni

18. Giovanni Bianchi, *The True History and Adventures of Catharine Vizzani, a Young Gentlewoman a Native of Rome, who for Many Years Past in the Habit of a Man; Was Killed for an Amour with a Young Lady; and Found on Dissection, a True Virgin. With Curious Anatomical Remarks on the Nature and Existence of the Hymen. By Giovanni Bianchi, Professor of Anatomy at Sienna, the Surgeon who Dissected Her. With a Curious Frontispiece* (London, 1755), 3–50.

19. Ibid., 34.

20. Ibid., 44.

21. Ibid.

## Charles aka Mary Hamilton

22. Donal Ó Danachair, ed., "Mary Hamilton a Woman who Was Imprisoned and Whipped for Marrying Fourteen Women, 1746," *The Newgate Calendar* 3 (2009): 35, *Ex-classics Project*, http://www.exclassics.com/newgate/ng03.pdf.

## Ann Marrow

23. Donal Ó Danachair, ed., "Ann Marrow Pilloried at Charing Cross, 22nd of July, 1777, for Marrying Three Women," *The Newgate Calendar* 4 (2009): 312, *Ex-classics Project*, https://www.exclassics.com/newgate/ng04.pdf

24. Ibid.

## Sitting in the Water Grizzly

25. Claude E. Schaeffer, "The Kutenai Female Berdache: Courier, Guide, Prophetess, and Warrior," *American Society for Ethnohistory* 12, no. 3 (Summer 1965): 196–197.

26. Ibid., 200.

27. Ibid., 215–217.

## Enriqueta aka Enrique Favez

28. Enrique Favez is also found as Enriqueta, Henriette, and Henri, and under the surname Faber or Fabes.

29. Juliana Martínez, "Dressed Like a Man? Of Language, Bodies, and Monsters in the Trial of Enrique/Enriqueta Favez and Its Contemporary Accounts," *Journal of the History of Sexuality* 26, no. 2 (May 2017): 189.

30. James J. Pancrazio, "Reescritura, invención y plagio: Enriqueta Faber y la escritura del travestismo," *La Habana Elegante* 56 (2014): 1–10, http://www.habanaelegante.com/Fall_Winter_2014/Invitation_Pancrazio.html, accessed September 23, 2017.

31. Julio César González Pagés, *Por andar vestida de hombre* (Havana: Editorial de la Mujer, 2012), 41.

32. Martínez, "Dressed Like a Man?," 193.

33. Ibid., 195.

34. Ibid., 202.

## Helen Oliver aka John Oliver

35. National Library of Scotland, "Broadside Report Regarding a Woman who Masqueraded as a Man, c. 1820," *The Word on the Street*, 2004, https://digital.nls.uk/broadsides/broadside.cfm/id/15324/transcript/1

36. Thomas Drew, "Hellen Oliver," in *The Lives and Portraits of Curious and Odd Characters* (Worcester, 1852), 159–162.

## Biawacheeitche or Woman Chief

37. Edwin Thompson Denig, *Five Indian Tribes of the Upper Missouri: Sioux, Arickaras, Assiniboines, Crees, Crows, ed. John C. Ewers* (Norman: University of Oklahoma Press, 1961), 196.

38. United States Bureau of American Ethnology, *Annual Report of the Bureau of American Ethnology to the Secretary of the Smithsonian Institution* (Washington: BAE, 1895), 433, https://ia600201.us.archive.org/30/items/annualreportofbu46smit/annualreportofbu46smit.pdf

39. James P. Beckwourth, *The Life and Adventures of James P. Beckwourth: Mountaineer, Scout, and Pioneer, and Chief of the Crow Nation of Indians*, ed. Thomas D. Bonner (New York: Harper and Brothers Publishers, 1856), 205.

## Rosa Bonheur

40. Martha Vicinus, *Intimate Friends: Women who Loved Women*, 1778–1928 (Chicago: University of Chicago Press, 2004), 16–18.

41. Ibid., 29.

## Billy or Sammy Williams

42. Emily Elizabeth Skidmore, "Exceptional Queerness: Defining the Boundaries of Normative U.S. Citizenship, 1876–1936" (dissertation, University of Illinois at Urbana-Champaign, 2011), 201.

43. Ibid., 202–203.

44. "Masqueraded as a Man," *The River Press* (Fort Benton, MT), December 16, 1908.

45. "'Ingeborge' Is Name of 'Sammy,'" *The Daily Missoulian*, January 1, 1909, morning edition. This story came out in numerous newspapers. The headline continues: "New York World Tells Story of Masquerading Woman—Is a Romance."

46. Peter Boag, *Re-Dressing America's Frontier Past* (Berkeley: University of California Press, 2011), 110.

47. Emily Skidmore, email to Ria Brodell, April 12, 2017.

## Captain Wright

48. "Extraordinary Discovery—A Female Husband," *The Bell's New Weekly Messenger* (London), December 14, 1834, 597.

49. "The Late Female Husband at Kennington—Further Particulars," *The Bell's New Weekly Messenger* (London), December 21, 1834, 607.

50. Ibid.

51. "Extraordinary Discovery," 597.

## Okuhara Seiko & Watanabe Seiran

52. Martha J. McClintock, "Okuhara Seiko (1837–1913): The Life and Arts of a Meiji Period Literati Artist" (dissertation, University of Michigan, 1991), 22.

53. Ibid., 112.

## Jeanne or Jean Bonnet

54. The San Francisco Lesbian and Gay History Project, "'She Even Chewed Tobacco': A Pictorial Narrative of Passing Women in America," a slide show based on primary research by Allan Bérubé, edited and reprinted in *Hidden from History: Reclaiming the Gay and Lesbian Past*, ed. Martin B. Duberman, Martha Vicinus, and George Chauncey (New York: New American Library, 1989), 187.

55. Kevin J. Mullen, "The Little Frog Catcher," in *The Toughest Gang in Town: Police Stories from Old San Francisco* (San Francisco: Noir Publications, 2005), 86.

56. Peter Boag, *Re-Dressing America's Frontier Past* (Berkeley: University of California Press, 2011), 36.

## Cora Anderson aka Ralph Kerwineo

57. Idah McGlone Gibson, "Amazing Double Life of Cora Anderson; Lived Thirteen Years as a Man; Dressed as a Man, Worked and Loved as Man," *Wilkes-Barre Times Leader* (PA), May 12, 1914.

58. "Girl Gets Eugenics License as Man," *Kalamazoo Gazette* (MI), May 10, 1914.

59. McGlone Gibson, "Amazing Double Life of Cora Anderson."

60. "Posed as a Man Ten Years and No One Ever Suspected That Cora Anderson Was a Girl," *Kansas City Star* (MO), May 8, 1914.

61. "Clothed as Man, Woman Is Locked Up," *Racine Journal-News* (WI), March 24, 1915.

## Petra "Pedro" Ruiz

62. Angeles Mendieta Alatorre, *La mujer en la Revolución Mexicana* (México: Instituto Nacional de Estudios Históricos de la Revolución Mexicana, 1961), 91.

63. Elena Poniatowska, *Las Soldaderas: Women of the Mexican Revolution*, trans. David Dorado Romo (El Paso, TX: Cinco Puntos Press, 2006), 20. The nickname "El Echa Balas" appears in many sources, sometimes translated as "The Shooter" or "Bullets."

64. "Mujeres de la Revolución: Petra Ruiz," Radio México Internacional, Mexico City: IMER con el Instituto Nacional de las Mujeres. Quotations were provided and translated by Vicente Guzman-Orozco. Poniatowska also mentions this event in *Las Soldaderas*, 20.

65. Poniatowska, Las Soldaderas, 20.

66. "Mujeres de la Revolución: Petra Ruiz."

67. El Nacional, November 8, 1959, partially quoted in Elizabeth Salas, *Soldaderas in the Mexican Military: Myth and History* (Austin: University of Texas Press, 1990), 47. Full quotation (uncited) in María Herrera-Sobek, *The Mexican Corrido: A Feminist Analysis* (Bloomington: Indiana University Press, 1990), 92.

## Olga Nikolaevna Tsuberbiller

68. Diana Lewis Burgin, *Sophia Parnok: The Life and Work of Russia's Sappho* (New York: New York University Press, 1994), 194.

## Naa Jian

69. Megan J. Sinnott, *Toms and Dees: Transgender Identity and Female Same-Sex Relationships in Thailand* (Honolulu: University of Hawaii Press, 2004), 54–55.

70. Ibid., 54.

71. Ibid.

## Jones or Jonesie

72. Makeda Silvera, "Man Royals and Sodomites: Some Thoughts on the Invisibility of Afro-Caribbean Lesbians," in "The Lesbian Issue," special issue of *Feminist Studies* 18, no. 3 (1992): 526–527.

73. Ibid., 527.

74. Ibid.

## Sakuma Hideka & Chiyoka

75. Jennifer Robertson, "Dying to Tell: Sexuality and Suicide in Imperial Japan," *Signs* 25, no. 1 (Autumn 1999): 28.

76. Ibid., 28–29.

# Bibliography

## Katherina Hetzeldorfer

Puff, Helmut. "Female Sodomy: The Trial of Katherina Hetzeldorfer (1477)." *Journal of Medieval and Early Modern Studies* 30, no. 1 (2000): 41–61.

Puff, Helmut. *Sodomy in Reformation Germany and Switzerland, 1400–1600.* Chicago: University of Chicago Press, 2003.

Rupp, Leila J. *Sapphistries: A Global History of Love between Women.* New York: New York University Press, 2009.

## Elena aka Eleno de Céspedes

Burshatin, Israel. "Written on the Body: Slave or Hermaphrodite in Sixteenth-Century Spain." In *Queer Iberia: Sexualities, Cultures, and Crossings from the Middle Ages to the Renaissance*, ed. Josiah Blackmore and Gregory S. Hutcheson, 427. Durham, NC: Duke University Press, 1999.

Kagan, Richard L., and Abigail Dyer. *Inquisitorial Inquiries: Brief Lives of Secret Jews and Other Heretics.* Baltimore: Johns Hopkins University Press, 2004.

Rupp, Leila J. *Sapphistries: A Global History of Love between Women.* New York: New York University Press, 2009.

Velasco, Sherry. *Lesbians in Early Modern Spain.* Nashville, TN: Vanderbilt University Press, 2011.

## Mary de Chaumont en Bassigni

Borris, K., ed. *Same-Sex Desire in the English Renaissance: A Sourcebook of Texts, 1470–1650.* New York: Routledge, 2004.

Montaigne, Michel Eyquem de. *Journal du Voyage de Michel de Montaigne en Italie, par la Suisse & l'Allemagne en 1580 & 1581.* Vol. 1. Paris: Chez Le Jay, 1774.

Montaigne, Michel Eyquem de. *Works of Michel de Montaigne: Comprising His Essays, Journey into Italy, and Letters.* Ed. William Hazlitt. Boston: Houghton, Mifflin and Company, 1887.

## D. Catalina "Antonio" de Erauso

de Erauso, Catalina. *The Autobiography of Doña Catalina de Erauso.* An Electronic Edition. Early Americas Digital Archive. College Park: University of Maryland, 2007. http://eada.lib.umd.edu/text-entries/ the-autobiography-of-dona-catalina-de-erauso/.

Pedrick, Dan Harvey. "The Sword and the Veil: An Annotated Translation of the Autobiography of Doña Catalina de Erauso." Master's thesis, University of Victoria, Victoria, BC, 1999.

Rupp, Leila J. *Sapphistries: A Global History of Love between Women.* New York: New York University Press, 2009.

Velasco, Sherry. *Lesbians in Early Modern Spain.* Nashville, TN: Vanderbilt University Press, 2011.

## Lisbetha Olsdotter aka Mats Ersson

Berg, P. G., and Wilhelmina Stålberg. "Olsdotter, Lisbetha." *Anteckningar om Svenska Qvinnor.* Projekt Runeberg, last modified July 3, 2016. http:// runeberg.org/sqvinnor/0324.html

Borgström, Eva. *Makalösa Kvinnor: Könsöverskridare i myt och verklighet.* Stockholm: Alfabeta/Anamma, 2002.

Fur, Gunlög. "Reading Margins: Colonial Encounters in Sápmi and Lenapehoking in the Seventeenth and Eighteenth Centuries." *Feminist Studies* 32, no. 3 (Fall 2006): 491–521.

Silverstolpe, Frederick, and Göran Söderström. *Sympatiens Hemlighetsfulla Makt: Stockholms Homosexuella 1860–1960.* Stockholm: Stockholmia förlag, 1999.

## Catharina Linck aka Anastasius

Crompton, Louis. *Homosexuality and Civilization*. Cambridge, MA: Harvard University Press, 2003.

Eriksson, Brigitte. "A Lesbian Execution in Germany, 1721: The Trial Records." *Journal of Homosexuality* 6, no. 1–2 (Fall 1980–Winter 1981): 27–40.

Norton, Rictor. "Catharina alias Anastasius." *Homosexuality in Eighteenth-Century England: A Sourcebook*, last modified June 13, 2008. http://rictornorton.co.uk/linck.htm

Rupp, Leila J. *Sapphistries: A Global History of Love between Women*. New York: New York University Press, 2009.

Zagria. "Anastasius Lagrantinus Rosenstengel (1694–1721) Button Maker, Prophet, Soldier." *A Gender Variance Who's Who: Essays on Trans, Intersex, Cis and Other Persons and Topics from a Trans Perspective*. September 26, 2010. https://zagria.blogspot.in/2010/09/anastasius-lagrantinus-rosenstengel.html?m=1

## Carl Lapp

Fur, Gunlög. "Reading Margins: Colonial Encounters in Sápmi and Lenapehoking in the Seventeenth and Eighteenth Centuries." *Feminist Studies* 32, no. 3 (Fall 2006): 491–521.

Rupp, Leila J. *Sapphistries: A Global History of Love between Women*. New York: New York University Press, 2009.

## James How aka Mary East & Mrs. How

Lysons, Daniel. "Stepney." *County of Middlesex*. Vol. 3. *The Environs of London*. London: T Cadell and W Davies, 1795. http://www.british-history.ac.uk/london-environs/vol3/pp418-488.

Norton, Rictor, ed. "Lesbian Marriages in 18th-Century England." *Homosexuality in Eighteenth-Century England: A Sourcebook*, last modified February 11, 2010. http://rictornorton.co.uk/eighteen/lesbmarr.htm

Norton, Rictor, ed. "Mary East, the Female Husband." *Homosexuality in Eighteenth-Century England: A Sourcebook*. December 6, 2003. http://rictornorton.co.uk/eighteen/1766east.htm

## Catterina Vizzani aka Giovanni Bordoni

Bianchi, Giovanni. *The True History and Adventures of Catharine Vizzani, a Young Gentlewoman a Native of Rome, who for Many Years Past in the Habit of a Man; Was Killed for an Amour with a Young Lady; and Found on Dissection, a True Virgin. With Curious Anatomical Remarks on the Nature and Existence of the Hymen. By Giovanni Bianchi, Professor of Anatomy at Sienna, the Surgeon who Dissected Her. With a Curious Frontispiece.* London: 1755.

Norton, Rictor, ed. "The Case of Catherine Vizzani, 1755." *Homosexuality in Eighteenth-Century England: A Sourcebook*, December 1, 2005. http://rictornorton.co.uk/eighteen/vizzani.htm

## Charles aka Mary Hamilton

Baker, Sheridan. "Henry Fielding's *The Female Husband*: Fact and Fiction." PMLA 74, no. 3 (1959): 213–224. http://www.jstor.org/stable/460583

Bowles, Emily. "You Have Not What You Ought: Gender and Corporeal Intelligibility in Henry Fielding's The Female Husband." *Genders Online Journal* 52 (2010). https://www.colorado.edu/gendersarchive1998-2013/2010/10/01/you-have-not-what-you-ought-gender-and-corporeal-intelligibility-henry-fieldings-female

Norton, Rictor. "Lesbian Marriages in 18th-Century England." *Homosexuality in Eighteenth-Century England: A Sourcebook*, last modified February 11, 2010. http://rictornorton.co.uk/eighteen/lesbmarr.htm

Ó Danachair, Donal, ed. "Mary Hamilton a Woman who Was Imprisoned and Whipped for Marrying Fourteen Women, 1746." *The Newgate Calendar* 3 (2009): 35. *Ex-classics Project*. http://www.exclassics.com/newgate/ng03.pdf

Rupp, Leila J. *Sapphistries: A Global History of Love between Women.* New York: New York University Press, 2009.

## Ann Marrow

Hitchcock, Tim. *English Sexualities, 1700–1800.* Ed. Jeremy Black. London: Macmillan, 1997.

Norton, Rictor. "Lesbian Marriages in 18th-Century England." *Homosexuality in Eighteenth-Century England: A Sourcebook*, last modified February 11, 2010. http://rictornorton.co.uk/eighteen/lesbmarr.htm

Ó Danachair, Donal, ed. "Ann Marrow Pilloried at Charing Cross, 22nd of July, 1777, for Marrying Three Women." *The Newgate Calendar* 4 (2009): 312. *Ex-classics Project*. https://www.exclassics.com/newgate/ng04.pdf

## Sitting in the Water Grizzly

Barry, Neilson J. "Ko-Come-Ne Pe-Ca, the Letter Carrier." *Washington Historical Quarterly* 20 (1929): 201–203.

Lang, Sabine. *Men as Women, Women as Men: Changing Gender in Native American Cultures*. Austin: University of Texas Press, 1998.

Rupp, Leila J. *Sapphistries: A Global History of Love between Women*. New York: New York University Press, 2009.

Schaeffer, Claude E. "The Kutenai Female Berdache: Courier, Guide, Prophetess, and Warrior." *American Society for Ethnohistory* 12, no. 3 (Summer 1965): 193–236.

Sperlin, O. B. "Two Kootenay Women Masquerading as Men? Or Were They One?" *Washington Historical Quarterly* 21 (1930): 120–130.

Williams, Walter L. *The Spirit and the Flesh: Sexual Diversity in American Indian Culture*. Boston: Beacon Press, 1986.

## Enriqueta aka Enrique Favez

González Pagés, Julio César. *Por andar vestida de hombre*. Havana, Cuba: Editorial de la mujer, 2012.

Martínez, Juliana. "Dressed Like a Man? Of Language, Bodies, and Monsters in the Trial of Enrique/Enriqueta Favez and Its Contemporary Accounts." *Journal of the History of Sexuality* 26, no. 2 (May 2017): 188–206.

Pancrazio, James J. "Reescritura, invención y plagio: Enriqueta Faber y la escritura del travestismo." *La Habana Elegante* 56 (2014): 1–10.

## Helen Oliver aka John Oliver

Drew, Thomas. *The Lives and Portraits of Curious and Odd Characters*. Worcester, MA: 1852.

National Library of Scotland. "Broadside Report Regarding a Woman who Masqueraded as a Man, c. 1820." *Word on the Street*. 2004. https://digital.nls.uk/broadsides/broadside.cfm/id/15324/transcript/1

Norton, Rictor. "Lesbian Marriages in 18th-Century England." *Homosexuality in Eighteenth-Century England: A Sourcebook*, last modified February 11, 2010. http://rictornorton.co.uk/eighteen/lesbmarr.htm

## Biawacheeitche or Woman Chief

Beckwourth, James P. *The Life and Adventures of James P. Beckwourth: Mountaineer, Scout, and Pioneer, and Chief of the Crow Nation of Indians*. Ed. Thomas D. Bonner. New York: Harper and Brothers Publishers, 1856.

Denig, Edwin Thompson. *Five Indian Tribes of the Upper Missouri: Sioux, Arickaras, Assiniboines, Crees, Crows*. Ed. John C. Ewers. Norman: University of Oklahoma Press, 1961.

Kurz, Rudolph Friederich. *Journal of Rudolph Friederich Kurz: An Account of His Experiences among Fur Traders and American Indians on the Mississippi and the Upper Mississippi Rivers during the Years 1846 to 1852*. Ed. J. N. B. Hewitt. Trans. M. Jarrell. Lincoln: University of Nebraska Press, 1970.

Lang, Sabine. *Men as Women, Women as Men: Changing Gender in Native American Cultures*. Austin: University of Texas Press, 1998.

Roscoe, Will. *Changing Ones: Third and Fourth Genders in Native North America*. New York: St. Martin's Press, 1998.

United States Bureau of American Ethnology. *Annual Report of the Bureau of American Ethnology to the Secretary of the Smithsonian Institution*. Washington: BAE, 1895. http://ia800201.us.archive.org/30/items/annualreportofbu46smit/annualreportofbu46smit.pdf

Williams, Walter L. *The Spirit and the Flesh: Sexual Diversity in American Indian Culture*. Boston: Beacon Press, 1986.

## Rosa Bonheur

Stanton, Theodore, ed. *Reminiscences of Rosa Bonheur*. New York: D. Appleton and Company, 1910.

Vicinus, M., ed. *Intimate Friends: Women Who Loved Women, 1778–1928*. Chicago: University of Chicago, 2004.

Vicinus, M., ed. *Lesbian Subjects: A Feminist Studies Reader*. Bloomington: Indiana University Press, 1996.

## Billy or Sammy Williams

Boag, Peter. *Re-Dressing America's Frontier Past*. Berkeley: University of California Press, 2011.

"Death Reveals the Secret." *Yellowstone Monitor* (Glendive, MT), December 17, 1908.

"'Ingeborge' Is Name of 'Sammy.'" *The Daily Missoulian* (Missoula, MT), January 1, 1909, morning edition.

"Masqueraded as a Man." *The River Press* (Fort Benton, MT), December 16, 1908.

"'Sammy Williams,' Nervy Hunchback, Was Woman." *St. Louis Post-Dispatch*, December 20, 1908.

Skidmore, Emily Elizabeth. "Exceptional Queerness: Defining the Boundaries of Normative U.S. Citizenship, 1876–1936." Dissertation, University of Illinois at Urbana-Champaign, 2011.

## Captain Wright

"Extraordinary Discovery—A Female Husband." *The Bell's New Weekly Messenger* (London), December 14, 1834.

"The Late Female Husband at Kennington—Further Particulars." *The Bell's New Weekly Messenger*, December 21, 1834.

## Okuhara Seiko & Watanabe Seiran

Fister, Patricia, and Fumiko Y. Yamamoto. *Japanese Women Artists, 1600–1900*. Lawrence, KS: Spencer Museum of Art, 1988.

McClintock, Martha J. "Okuhara Seiko (1837–1913): The Life and Arts of a Meiji Period Literati Artist." Dissertation, University of Michigan, 1991.

McClintock, Martha J., and Victoria Weston. "Okuhara Seiko: A Case of Funpon Training in Late Edo Literati Painting." I*n Copying the Master and Stealing His Secrets: Talent and Training in Japanese Painting*, ed. Brenda G. Jordan and Victoria Weston, 116–146. Honolulu: University of Hawaii Press, 2003.

## Jeanne or Jean Bonnet

Boag, Peter. *Re-Dressing America's Frontier Past*. Berkeley: University of California Press, 2011.

"Brevities." *Daily Alta California*, December 17, 1875.

"By State Telegraph." *Sacramento Daily Union*, September 16, 1876.

Mullen, Kevin J. "The Little Frog Catcher." In *The Toughest Gang in Town: Police Stories from Old San Francisco*. San Francisco: Noir Publications, 2005.

Rupp, Leila J. *A Desired Past: A Short History of Same-Sex Love in America*. Chicago: University of Chicago Press, 1999.

The San Francisco Lesbian and Gay History Project. "'She Even Chewed Tobacco': A Pictorial Narrative of Passing Women in America." A slideshow based on primary research by Allan Bérubé. Edited and reprinted in *Hidden from History: Reclaiming the Gay and Lesbian Past,* ed. Martin B. Duberman, Martha Vicinus, and George Chauncey. New York: New American Library, 1989.

Zagria. "Jean Bonnet (1849–1876), Frog Catcher." *A Gender Variance Who's Who: Essays on Trans, Intersex, Cis and Other Persons and Topics from a Trans Perspective*. January 9, 2012. https://zagria.blogspot.com/2012/01/jean-bonnet-1849-1876-frog-catcher.html

## Cora Anderson aka Ralph Kerwineo

"Clothed as Man, Woman Is Locked Up." *Racine Journal-News*, March 24, 1915.

Cromwell, Jason. *Transmen and FTMs: Identities, Bodies, Genders, and Sexualities*. Chicago: University of Illinois Press, 1999.

"Former Girl Man Again Arrested." *Milwaukee Sentinel*, June 9, 1919.

"Girl Gets Eugenics License as Man." *Kalamazoo Gazette*, May 10, 1914.

McGlone Gibson, Idah. "Amazing Double Life of Cora Anderson; Lived Thirteen Years as a Man; Dressed as a Man, Worked and Loved as Man." *Wilkes-Barre Times Leader*, May 12, 1914.

"Posed as a Man Ten Years and No One Ever Suspected That Cora Anderson Was a Girl." *Kansas City Star,* May 8, 1914.

Skidmore, Emily. "Ralph Kerwineo's Queer Body: Narrating the Scales of Social Membership in the Early Twentieth Century." *GLQ: A Journal of Lesbian and Gay Studies* 20, no. 1–2 (2014): 141–166.

Somerville, Siobhan B. *Queering the Color Line: Race and the Invention of Homosexuality in American Culture*. Durham, NC: Duke University Press, 2000.

"Thirteen Years a Girl-Husband." *The Ogden Standard* (Ogden City, UT), magazine section, June 13, 1914.

## Petra "Pedro" Ruiz

Alatorre, Angeles Mendieta. *La mujer en la Revolución Mexicana*. México: Instituto Nacional de Estudios Históricos de la Revolución Mexicana, 1961.

Chávez, Lucila. "Quien Lleva los Pantalones? Female Subversion and Queerness in the Mexican Revolution." *Loudmouth* 9 (Spring 2005): 14. https://www.yumpu.com/en/embed/view/n8gurAQc0KXV9SZR

Chávez, Lucila. "Quien Lleva los Pantalones? Writing Female Cross-Dressers into the History of the Mexican Revolution." Dissertation, California State University, Los Angeles, 2005.

Herrera-Sobek, María. *The Mexican Corrido: A Feminist Analysis*. Bloomington: Indiana University Press, 1990.

Leimer, Ann Marie. "'Crossing the Border with "La Adelita"': Lucha-Adelucha as 'Nepantlera' in Delilah Montoya's 'Codex Delilah.'" *Chicana/Latina Studies* 5, no. 2 (2006): 22–23.

Poniatowska, Elena. *Las Soldaderas: Women of the Mexican Revolution*. Trans. David Dorado Romo. El Paso, TX: Cinco Puntos Press, 2006.

Salas, Elizabeth. *Soldaderas in the Mexican Military: Myth and History*. Austin: University of Texas Press, 1990.

## Frank Blunt & Gertrude Field

Katz, Jonathan. *Gay American History: Lesbians and Gay Men in the U.S.A*. New York: Crowell, 1976.

Lesy, Michael. *Wisconsin Death Trip*. New York: Pantheon, 1973.

"She Posed as a Man." *The Aurora Daily Express* (Aurora, IL), July 14, 1893.

## Olga Nikolaevna Tsuberbiller

Burgin, Diana Lewis. *Sophia Parnok: The Life and Work of Russia's Sappho*. New York: New York University Press, 1994.

Healey, Dan. *Homosexual Desire in Revolutionary Russia: The Regulation of Sexual and Gender Dissent*. Chicago: University of Chicago Press, 2001.

Шерстобитова, К. Б. "НЕИЗВЕСТНОЕ ОБ ИЗВЕСТНОЙ." *Fine Chemical Technologies (Vestnik MITHT)* (2010): 37–43. Anniversary Issue.

Тоотс, Н. А. *Беседы Учителя. Как прожить свой серый день*. Книга I. Moscow, 2010. http://cr-cefeya.com.ua/files/teacher%20talks1.pdf

Шерстобитова, К. Б. 2010. "НЕИЗВЕСТНОЕ ОБ ИЗВЕСТНОЙ." *Fine Chemical Technologies (Vestnik MITHT)*, 37–43. Anniversary Issue.

## Naa Jian

Sinnott, Megan J. *Toms and Dees: Transgender Identity and Female Same-Sex Relationships in Thailand*. Honolulu: University of Hawaii Press, 2004.

## Jones or Jonesie

Brodell, Ria. "Re: Miss Jones or Jonesie." Facebook message to Makeda Silvera, June 17, 2016.

Silvera, Makeda. "Man Royals and Sodomites: Some Thoughts on the Invisibility of Afro-Caribbean Lesbians." "The Lesbian Issue," special issue of *Feminist Studies* 18, no. 3 (1992): 521–532.

## Big Ben

Wilson, James F. *Bulldaggers, Pansies, and Chocolate Babies: Performance, Race and Sexuality in the Harlem Renaissance*. Ann Arbor: University of Michigan Press, 2010.

"Women Rivals for Affection of Another Woman Battles with Knives, and One Has Head Almost Severed from Body." *New York Age*, November 17, 1926.

Woolner, Christina A. "'The Famous Lady Lovers': African American Women and Same Sex Desire from Reconstruction to World War II." Dissertation, University of Michigan, 2014.

## Sakuma Hideka & Chiyoka

Hideka, Sakuma. "Joshi Ketsui suru made" (Until [we] resolved to commit love suicide). *Fujin Gahô*, 1934.

Robertson, Jennifer. "Dying to Tell: Sexuality and Suicide in Imperial Japan." *Signs* (Chicago) 25, no. 1 (Autumn 1999): 1–35.

"Watashi wa koi no shorisha" (I am a survivor of love). *Asahi Shinbun* (Tokyo), June 14, 1934, morning edition.

# Ria Brodell

Photograph by Chris Brodell

Ria Brodell is an artist and educator based in Boston who has had solo and group exhibitions throughout the United States, with work featured in the *Guardian*, *ARTNews*, the *Boston Globe*, and *New American Paintings*.